BEYOND LOGOS

NEW DEFINITIONS OF CORPORATE IDENTITY

RotoVision

A RotoVision Book
Published and distributed
by RotoVision SA, Route Suisse 9,
CH-1295 Mies, Switzerland

RotoVision SA, Sales and
Production Office
Sheridan House,
112/116A Western Road
Hove, East Sussex
BN3 1DD, UK

Tel: +44 (0)1273 72 72 68
Fax: +44 (0)1273 72 72 69
Email: sales@rotovision.com
Web: www.rotovision.com

10 9 8 7 6 5 4 3 2 1

ISBN 2-88046-697-0

Book design by SEA

Originated by Hong Kong Scanner Arts

Printed and bound in China by
Midas Printing

BEYOND LOGOS

NEW DEFINITIONS
OF CORPORATE
IDENTITY

CLARE DOWDY

CONTENTS

INTRODUCTION

FOR MOST OF THE LAST CENTURY, COMPANIES HAD A CORPORATE LOGO, AND DEPENDING ON THEIR BUSINESS, THEY MIGHT ALSO HAVE HAD CONSUMER BRANDS. IN THOSE DAYS, BRAND GENERALLY REFERRED TO A PRODUCT RATHER THAN A SERVICE. THE LOGO AND THE BRANDS THAT SAT BENEATH IT WERE SEEN AS WAYS OF EXPRESSING WHAT THE COMPANY DID, WHICH NORMALLY MEANT WHAT PRODUCT THE COMPANY SOLD.

"DESIGN BECAME IDENTITY, IDENTITY BECAME BRANDING, BRANDING BECAME LIVING IT."

PETER KNAPP, LANDOR

In the 1980s and 1990s, more competitors entered the marketplace through market forces and deregulation, which in turn triggered mergers and acquisitions. With so many players after consumers' money, companies increasingly needed to differentiate their offers.

But as products and services came to resemble each other more and more closely in terms of quality and cost, this became difficult. It was then that people began to realise that their brand and its values (that is, what it stood for) were one of the few noticeable differentiators.

Towards the end of the century, there was the realisation that a strong brand could stretch or even jump into other sectors – so supermarkets got into financial services, and the UK chemist Boots paired up with the UK TV producers Granada to launch a Wellbeing TV channel.

The continued commercialisation of so many elements of life means that in recent times, branding skills have been extended into hitherto untouched sectors. The charity sector (Scope), pop music (Hear'Say), football clubs (Manchester United), and even countries (Spain and Estonia), see themselves as competing for audiences, and branding consultancies have leapt in. Hence whole sectors have been put through the positioning and branding mill in a way that would have been unthinkable ten or 20 years ago.

At the same time, there has been a blurring of the boundaries between product and service. There is hardly a product out there which does not have some service element, even if it is just a call centre to field complaints about faulty goods. This raises issues around the manifestation of the brand – where and how it is seen and by whom – and how the people who work with it behave.

Design Week magazine editor Lynda Relph-Knight describes this move as being "away from a manufacturing company to a service company, that is from product to branding and service, where you are selling a promise".

This move was also away from a purely visual manifestation of a corporate or brand culture, which approach, she says, didn't take into account a company's "touchy-feely things", except perhaps its office reception area.

The key is experience. "Design became identity, identity became branding, branding became living it," says Peter Knapp at Landor in London. Audience expectations have changed so that products now need to create an experience around the transaction or interaction with them. From clothing accessories label Mandarina Duck opening individually designed 'embassies' to the deodorant Lynx's (now defunct) barbershop chain, the emphasis is on intensifying the customer experience to encourage them to stay loyal.

THERE IS AN EVER-GROWING NUMBER OF PLATFORMS FOR BRANDS. THIS MEANS IMBUING EACH OF THEM WITH THE RELEVANT BRAND VALUES.

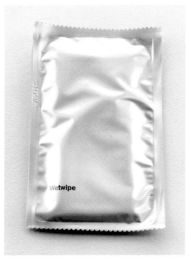

In the 1990s these experiences were intended, in part at least, to counter the threat of e-commerce. That threat has largely abated for the moment, but the need to create meaningful experiences continues. FMCGs (fast-moving consumer goods) are unable to control every retail environment – and what position they take on shelf – but they can control at least some if they create their own stores. Hence the Guinness Storehouse experience by Imagination, the Lucky Strike concept shop in Amsterdam by Fitch, and BDP's NikeTown.

Staff are now seen as the most important ambassadors a product or service can have. They provide the human interaction with that other core audience, the customer, as well as the investors, analysts and suppliers. If staff are not 'on brand', the reputation of that product or service will suffer. Hence the huge amount of work that is going on in internal communications, or what is now known in some quarters as internal branding. This includes schemes which reward staff whose behaviour reflects specific brand values. BP has worked on this with Landor and Enterprise IG, and Fitch is helping the Belgian post office De Post do this. Global communications network WPP is so keen on the sector that it bought in one of the UK's internal marketing specialists, MCA Group.

There is an ever-growing number of platforms for brands. Intranet sites, merchandise, office interiors, showrooms, exhibitions, live events, sponsorship, internal communications, and even the very sound a product or service makes are all seen as needing to be 'on message'. This means imbuing them each with the relevant brand values.

For all these platforms have any number of treasured audiences. And some people fall into more than one audience category, so the message must be clear and consistent.

However, the pool of adjectives from which companies take their values is not so big, and there is the risk of repetition and missing that Holy Grail – differentiation. That's where the expression of those values by the consultancy comes into play. 'Innovative and caring' can mean different things to different companies, depending on the way it's expressed through their literature, office interiors, staff behaviour, internet site, sound, sponsorship programmes and such like.

Wetwipe
The humble wetwipe is proof that branding need not be about logos. This is not just any wetwipe, but that of Scandinavian airline SAS. Stockholm Design Lab worked on brand development and implementation for the airline's revamp following initial work by FutureBrand in the UK.

SAS's wetwipe is the most popular in the airline industry. They know this from surveying what's left on passengers' meal trays, and it is the most stolen item off any tray.

The reason for this, according to SDL's Göran Lagerström, is that this item is totally unbranded. "It's the most stolen item because it's fairly good-looking and you need a wetwipe, but you don't want to walk around with advertising. It becomes yours because it's unnamed." And at the same time, he claims, it becomes SAS's identity.

This understated approach to branding – Wolff Olins showed it off to great effect with Orange – is more in keeping with today's consumer, says Largerström. "This process works because people have been violated by overexposure."

The average airline has more than 3,000 items, and most have the identity on them. "With SAS we started something in the airline industry. This is an organic approach rather than a mechanical one – one identity with different expressions," Largerström adds.

THERE IS A FEELING AMONG SOME CLIENT BRAND MANAGERS AND MARKETERS THAT RASH IDENTITY OVERHAULS OR UNNECESSARY NAME CHANGES CAN THROW THE BABY OUT WITH THE BATH WATER.

The season for name changes and identity overhauls has been and gone – for the time being. Only a company that has to, changes its name; whether that's for legal reasons, like Andersen Consulting becoming Accenture (courtesy of Landor), or to improve perception (like Interbrand's renaming of the Spastics Society to Scope), or for expansion reasons, like Wolff Olins' name, Orange, becoming the brand for all Hutchinson Telecom's businesses.

And anyway, there is a feeling among some client brand managers and marketers that rash identity overhauls or unnecessary name changes can throw the baby out with the bath water. The UK Post Office holding group's unpopular transformation into Consignia (by Dragon) could fall into this category. Staff, the press and the public alike were baffled at the reasons behind the change, the meaning of the new name, and the sentiments supposedly incorporated in the logo.

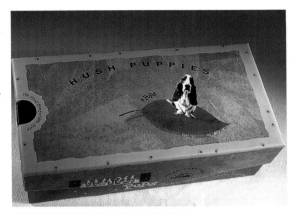

Left
Fitch:London advised Hush Puppies against changing their identity but rather to refresh the look.

Below
GBH's identity
for Teleconnect
was specifically
designed to be
adaptable.

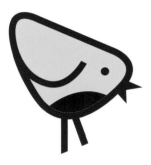

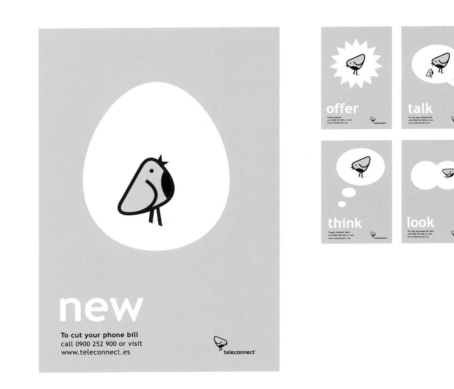

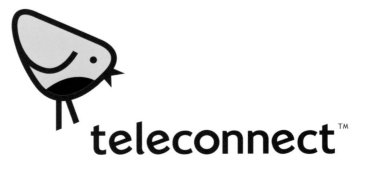

BRANDING IS A RELATIVELY MODERN PHENOMENON, THE INDUSTRY THAT SERVES IT IS STILL YOUNG, AND OWNERSHIP OF THE WORD "BRAND" HAS YET TO SETTLE WITH ONE PARTICULAR TYPE OF BUSINESS.

And as clients are now tightening their marketing budgets, major overhauls are seen as an indulgence. Much better, they seem to be thinking, to work with what we've got and improve the expression of our existing marque. This is what Interbrand is doing with Orange, what SiegelGale did with Motorola and Dow in the US, and what Enterprise IG did with BT. Some consultancies even advise against making massive changes if they think a refreshment of the 'look and feel' of a brand is all that's needed. This is exactly what Fitch did with Hush Puppies.

This means that brand consultancies' relationships with some clients have changed from being on a (usually very costly) project basis, to a brand guardian role. It may not sound as sexy, but it's steady work and keeps the consultancy near the top of the food chain – since it is the CEO who is likely to make any decision regarding his company's brand.

However, all this manifestation work should not mean bland uniformity. In fact predictable consistency has been replaced by variety.

Either the logo itself is adaptable, as in the case of GBH's Teleconnect, and Allevio's identity for eLearning in Austria, or the execution is varied. Audiences are now sophisticated enough to be able to recognise a product or service without being swamped with actual logo applications. Good branding means the values are expressed beyond the logo. Take Wolff Olins' Orange and The Economist magazine (which was worked on by FutureBrand through MetaDesign), both of which are easily identifiable by their literature or advertising without the logo on view. This is what Landor has tried to achieve with its branding of BMI British Midlands.

Fitch is having a similar experience: "We've found that we are taking brands beyond where they have traditionally been," says John Mathers at Fitch in London. For example, the consultancy is advising Premier Automotive Group merchandise strategy for Ford and Jaguar.

Brands therefore need to cross an increasing variety of platforms, reaching specific or sometimes multiple audiences. They need to be able to carry a new business offer, and to tie up with an unlikely partner. This means the branding has to be strong and flexible.

With all these extra demands made on them, the consultancies have found a number of ways to exploit the potential: either as multi-skilled one-stop-shops, or as part of bigger networks, or as specialist groups which can team up with other specialist consultancies.

The issue of brand is, however, further muddied by the very people who claim to be offering advice on the subject. Branding is a relatively modern phenomenon, the industry that serves it is still young, and ownership of the word 'brand' has yet to settle with one particular type of business.

From design companies which now do strategy, to brand consultancies which still focus on design; from ad agencies to management consultancies, everyone wants to own the client's brand. Each of these types of businesses has something to offer, and it's up to the client to pick through and work out what they need.

But whether a designer claims to work on logos, identities or brand programmes, the chances are some of the difference is just a matter of terminology. "One of the big changes has been terminology," says Relph-Knight. A change that Wolff Olins co-founder, Wally Olins, is credited with.

eLearning DIY marques
eLearning Austria is an online learning initiative from that country's Ministry of Education, Science and Art. Local brand consultancy, Allevio, has come up with an icon for the service which will double as a mascot. Breaking the icon down, it uses an @ symbol with an O as the first letter of Austria's German name, Osterreich.

This mascot appears on various media, and is used as emoticons for online chat forums. Similar to GBH's Teleconnect branding, Allevio has created 28 different 'facial' expressions for the mascot. "This makes it much more personal and flexible than conventional brands which lose recognition as soon as a detail is changed," says Mario Gagliardi at Allevio.

The eLearning service is accessed through a web portal by school pupils, teachers and parents. There are plans to expand the portal, making it the main access information point for Austrian culture and science.

Allevio is even prepared to give up ownership of the brand, by encouraging users who use it to draw their own versions, and incorporate them into the different eLearning applications. "It was designed so that it could be easily hand-drawn by anybody, and we will actually invite people to come up with their own versions – quite the opposite of a conventional, rigid brand which constantly has to be controlled and obtains its value by being 'unique'," Gagliardi adds. "The more variations that people make, the more the brand can soak up trends and opinions, working as an intermediary signifier between people and the idea of eLearning."

This is all in the spirit of the service, he says. "Learning cannot be 'owned' in the sense of 'property', it is a personal process involving creativity and interaction, and this is conceptually expressed in the brand."

Right
MetaDesign,
now part of
FutureBrand,
bringing the
Economist
brand alive.

Right
The eLearning
marque has
28 'facial'
expressions,
designed by
Allevio.

CHAPTER 1
BLURRING BOUNDARIES

451°F STORE
FORD FLEXIVITY
GUINNESS STOREHOUSE
VW AUTOSTADT
VIZZAVI
WELLBEING
CONCORDE
MOTOROLA
AUDI
VÅRDFÖRBUNDET

BLURRING BOUNDARIES

THE FRONTIERS FOR BRANDS ARE BEING PUSHED ALL THE TIME. WHO WOULD HAVE EXPECTED SUPERMARKETS TO GET INTO FINANCIAL SERVICES, AS THEY DID IN THE UK IN THE 1990S, OR AN INSTANT COFFEE TO SET UP A CHAIN OF COFFEE SHOPS?

THESE SORTS OF VENTURES HAVE BLURRED THE BOUNDARIES BETWEEN PRODUCTS AND SERVICES, AS BRANDS COMPETE FOR OUR HEARTS AND MINDS THROUGH AN EVER-INCREASING ARRAY OF PLATFORMS.

New platforms have been spawned by three factors: new technology, new partnerships and new business opportunities. For technology, read the internet.

Such platforms for an FMCG often mean introducing a service element for the first time. And this is where the concept of 'experience' comes in.

The blurring of boundaries between product and service means that the high street is now peppered with new entrants. Even an FMCG can have aspirations of engaging consumers in an experience. Hence Nescafé, previously only seen before on supermarket shelves, trialled a Nescafé coffee chain in London – a concept that seems to fly in the face of current coffee bar trends, but that's not stopping them.

For products are rarely able to control their own environments. They are victims of a third party retailer. They might be able to dictate where they appear in the shelving hierarchy, or they can create more of a splash for themselves by investing in concessions, but many products now have loftier aims. FMCGs and other products spend millions on brand awareness – gripping ad campaigns, innovative direct mail, packaging with stand-out – and now they are harnessing that investment and redirecting it into experience. Lucky Strike is BAT's lead brand for its concept store in Amsterdam, called 451°F; men's toiletries brand Lynx had a Lynx-branded barbershop on London's Oxford Street, designed by Londoners, Jump; Guinnness has its Storehouse in Dublin – a themed entertainment zone – and Ford Motor Company has an outlet outside San Diego where customisation is king.

Not only does having your own space allow you to control absolutely the way your product is presented, it is also an opportunity to engage new audiences. Ford was after those elusive 'millennials' when it opened its Flexivity store – kids under 20 who had either no relationship with or a negative perception of the Ford nameplates. Guinness, too, saw sales sliding among the young. Reuters, meanwhile, has opened a tasteful, high-tech internet bar next to its Fleet Street HQ in London. Designed by London group Hodges Associates, it is hoping to attract non-Reuters subscribers as well as existing punters.

Purely functional retailing is no way to engage the modern consumer. Nike knew this when it unveiled the first NikeTown in the US. Italian accessories brand Mandarina Duck has also taken this on board, handpicking a string of high profile designers to create its 'embassies' around the world.

It's the same with Ford's Flexivity store in the US. There, those elusive young customers are encouraged to get into Ford by customising their cars with spray paint and bespoke seat covers.

But experience brings with it an element of business that FMCGs have never had to think about before – customer-facing staff. Nescafé needed staff to man its coffee shops. Men's toiletries brand Lynx had to introduce Lynx-style barbers to serve and interact with its punters. How these staff behave is key to the way in which consumers experience the brand (see Chapter 3).

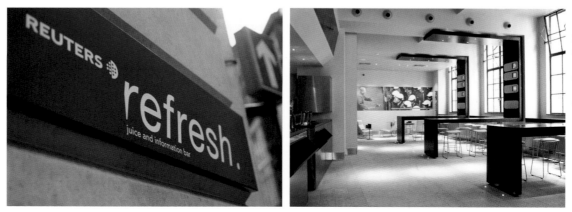

Left
Reuters gets 3D with its Fleet Street bar in London, designed by Hodges Associates.

EXTENSIONS THROUGH PARTNERSHIPS

Some of the branding issues that such partnerships can struggle with are echoed by that other phenomenon of the last few years – organisations throwing themselves and their brand into new areas of business. "We are finding that we are taking brands beyond where they have traditionally been," says John Mathers at Fitch, citing the work Fitch does on merchandise strategy for Premier Automotive Group, Ford and Jaguar.

And regardless of the strength of the brand, success is not guaranteed. The short-lived Lynx barbershop idea proves that. A Lever Fabergé spokeswoman had this to say on the closing of the sites: "We took the business decision in December [2001] to close the barbershops as despite creating an experience that our customers loved, we were not reaching the exacting business targets that Lever Fabergé demands of all its activities and ventures."

But high-street experiences are only one direction a brand can go. And you don't necessarily have to go it alone. Trusted brands are able to move into new areas through unexpected partnerships. The consumer nowadays is more accepting of these relationships – at least in theory – if the brands are in some way complementary, and if the consumer can see the benefits.

Unlikely partnerships, though, can lead to unexpected problems, as Granada Media and Boots discovered when they went into business together. And unexpected problems can leave the branding consultancy foundering. Marrying the values of two very different organisations could hardly be described as straightforward – creating an identity for any corporate merger, even of similar business, proves that. But when one or more of the parties is moving into a completely new area of business, the problems are exacerbated. London graphics consultancy 4i was responsible for the branding of the short-lived TV channel set up by Boots and Granada. "Creating a consistent identity for a completely new brand – owned by two such established companies – is an enormous challenge," said Mark Norton at 4i at the time. In retrospect, this reads like an understatement.

"WE ARE FINDING THAT WE ARE TAKING BRANDS BEYOND WHERE THEY HAVE TRADITIONALLY BEEN."
JOHN MATHERS, FITCH

With new platforms come new ways of brand expression. One of the hottest ways to express identity is through sound. An increasing number of consultancies are offering an audio rendering of a brand alongside the visual manifestation. This exploits two things – the determination of brands to be all-pervasive, and the variety of technological platforms that brands are now expected to perform across. This could be when you access a website, when you are on hold, in-store, using a WAP service, or wherever else technology takes us.

At the moment this phenomenon is in the hands of a handful of practitioners – there aren't many musicians out there who are prepared or able to throw their hats into the branding ring. Oslo-based group Både Og is one of the longest-running such businesses, and has worked for Bosch and Peugeot in Norway. Interbrand has a fledgling in-house audio branding capability in London. Many of the other consultancies – Wolff Olins, Enterprise IG, Basten Greenhill Andrews and Identica – team up with Sonicbrand, founded by a duo from the advertising world who in turn pull in freelance composers.

The theory goes that a brand's sound must tally with its values. That means a product or service which sees itself as caring and traditional should have a sound to match. Sonicbrand sets out to develop "a language which will express those values in sound", says co-founder, Dan Jackson. He calls it the audio brand guideline. In other words, a visual logo can be complemented with an audio 'logo' lasting a couple of seconds. The Intel Pentium 'logo' that is tacked on to the end of every radio and TV commercial is an obvious example. In the old days this would have been called a jingle, but sound has taken advantage of branding's climb up the marketing agenda. As a consequence, the jingle's status improved and its terminology has been updated.

This initial composition can then stretch to be the music you hear when you're on hold, in the same way that a logo gets a new and fuller lease of life when it is part of a complete literature system.

But our hearing isn't the only sense which is getting the brand treatment. Smell is coming in too, as the perfume industry takes on the challenge of creating scents to represent brands. Even UK DIY tools brand Black & Decker could have a smell – something macho and oily no doubt. "Aural branding and olefactory branding will become more mainstream, particularly for retail concessions," predicts Kate Ancketill, from the design-client matchmaking service GDR.

Storytelling

John Simmonds at Interbrand in London wrote the book called Believe to help tell the story of the Guinness brand to internal audiences. "The intention was to get a greater consistency in the way Guinness is portrayed," says Simmonds.

Believe is based around six Guinness heroes, and features stories that have made the Guinness brand great. The stories were then used to develop external communications and advertising. "Storytelling has developed over the last few years," says Simmonds. "Brands are looking for ways of differentiating themselves. But the stories have to be absolutely pertinent to the company, for customers, potential customers and staff."

THE THEORY GOES THAT A BRAND'S SOUND MUST TALLY WITH ITS VALUES. THAT MEANS A PRODUCT OR SERVICE WHICH SEES ITSELF AS CARING AND TRADITIONAL SHOULD HAVE A SOUND TO MATCH.

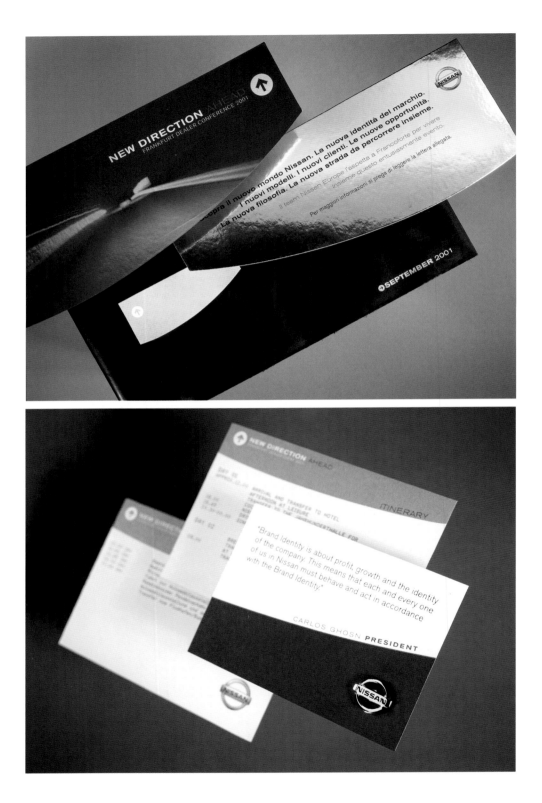

Below
Fitch:London
communications
material
developed for
Nissan helped
build the brand
amongst
employees and
Nissan partners.

PRODUCT AS BRAND

As one of the last design disciplines to get on the branding bandwagon, product design is catching up fast. No longer are product designers expected to develop something that's merely functional or aesthetic. It's got to exude a string of brand values too. This has implications for the identity consultancy who comes up with these values, as it's no longer just shops, stationery and websites that need to be 'on message'.

Conventional visual manifestations of a brand are starting to become old hat. The designers at Wolff Olins appreciated this when they created the brand for the telecomms entrant, Orange, in the 1990s. Everything the telecomms company puts out, from ad campaigns to marketing literature, is executed in such a strong style – originated by Wolff Olins – that the actual logo needn't appear at all. The Economist's ads are similarly executed, though this time the magazine has taken ownership of a typeface, colour and tone.

For consumers have been overloaded with logos and marques for too long, and a logo on its own no longer carries the weight it once did. In fact in recent years there have been signs of a backlash against the very logo itself. Some people are fed up with the overexposure, carrying their logos around on clothes, bags and accessories.

This is certainly the belief of Göran Lagerstrom at Sweden's Stockholm Design Lab: "People were just stamping things with their marque, like cows in Texas."

Consultancies are waking up to this, and a more subtle, less patronising approach is emerging. And this is where product design can come into its own. If a product, be it a phone or a washing machine, can tell you where it came from without you having to squint at the logo, that's surely a more effective way of brand expression. Sony didn't seem to think so in the 1980s – that was when their products sported a hastily applied sticker reading 'It's a Sony', in case the consumers couldn't tell. Those distinctive Mercury phone boxes of the 1980s tell another story. And in more recent times, Apple, Motorola, Electrolux, BT and Concorde have all twigged, and with varying degrees of success are making their products work harder. The Apple iMac, that epitome of effective product design, is the standard that all other products must live up to.

Of course, some of the change is in the semantics rather than the behaviour. Product designers would argue that they've always taken the corporate culture into consideration. "Everything we do in-product is about giving a product a brand. It's a change in language. It's not an evolution in product design but of the market that we sell our services in," says Adam White at Factory in London.

IF A PRODUCT – BE IT A PHONE OR A WASHING MACHINE – CAN TELL YOU WHERE IT CAME FROM WITHOUT YOU HAVING TO SQUINT AT THE LOGO, THAT'S SURELY A MORE EFFECTIVE WAY OF BRAND EXPRESSION.

Electrolux appreciates that it has a plethora of 43 well- or lesser-known white goods brands it has accumulated through acquisition across Europe, and in order to achieve higher brand awareness, product consistency is needed. Thus, a process of brand rationalisation is being carried out in Pordenone, Italy.

Motorola, on the other hand, saw it was missing a trick with its unmemorable phone products, and has set about launching a new range which should be recognisable as from the Motorola stable. It's up to head of design Tim Parsey to deliver this through the organisation's handful of design centres around the world. He has the sizeable task of instilling 'Motorolaness' into these gadgets, and in the process changing the company from being engineering to design focused.

The art of conjuring a branded range through product design is, however, a complex one. "Creating an identity across a range is not easy, it's not just about button detailing, it's subtler than that," says Adam White at Factory.

These changes in what a product or service can do, and how it can behave, have a significant impact on designers. Clients seem to have two options. They can either expect consultancies to offer everything – from identity creation to live events, product design, retail environments, merchandise and back to marketing material. Or, clients can put together teams of specialists to work together. The implications of this are discussed in Chapter 4. Clients, too, are changing. No longer is the product brand manager responsible for an FMCG. "In the past they were responsible for a product rather than the brand strategy," says Nick Moon at FutureBrand. As FMCG manufacturers like Unilever pull back to focus on their core products, "the role of the product brand manager is being taken over by strategy brand managers", he says. And this is who the designers, whether they are doing the packaging, retail environment, website or direct mail, will be dealing with.

At the same time, all this blurring of conventional boundaries has put consultancies at a potential advantage. Fitch's John Mather says: "Brands are moving into areas where they have no expertise, so the consultancy knows more."

THESE CHANGES IN WHAT A PRODUCT OR SERVICE CAN DO, AND HOW IT CAN BEHAVE, HAVE A SIGNIFICANT IMPACT ON DESIGNERS.

Below
Scion logo
developed by
Lexicon.

Capturing the young

Companies are trying all sorts of tricks to appeal to their target audience. And catching the attention of young adults is one of the hardest things to pull off. Toyota are trying it through editorial.

Toyota launched a car brand aimed at young buyers in March 2002. The new brand will sit alongside the Toyota and Lexus brands. The name, Scion, was developed by San Francisco naming company, Lexicon, in conjunction with the car manufacturer. Toyota then brought in LA consultancy Fresh*Machine to create an identity that would work across a number of platforms.

Fresh*Machine describes itself as a digital and strategic firm. It was set up in 2001 by Rick Bolton, who was director of broadband and interactive TV at Razorfish in LA, and business consultant Glen Martin. Fresh*Machine created the identity with the Rebel Organisation, which is the marketing arm of US magazine URB.

The design team was appointed and started working on Scion before it had even seen the product. The logo had to work as a badge on the vehicles, as well as on the website and kiosks – both of which were also designed by Fresh*Machine.

Rather than national advertising, Scion's launch was promoted through what Scion's national manager Brian Bolain calls an "'under the radar' approach that is more subtle, rather than 'in your face'." Given the attitude of the target audience, this sounds wholly appropriate.

For example, the launch website offers music downloads, lifestyle articles and opinion polls as well as photos and video previews of the cars.

"Scion has been announced for the US only during its launch phase. No firm decision has been made regarding other countries," says Bolain.

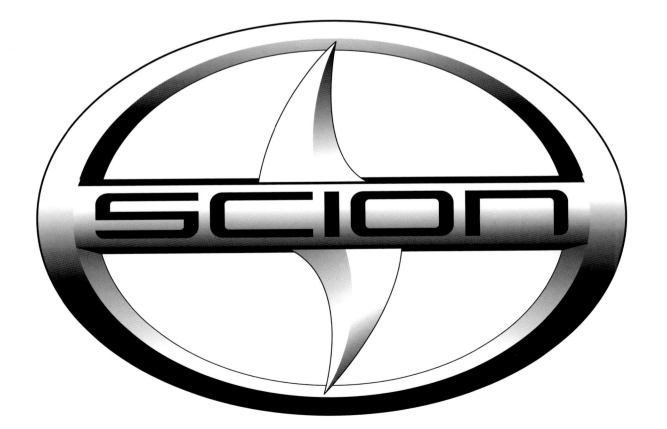

CASE STUDY
451°F STORE

PRESENTING LUCKIES AS A LIFESTYLE

Tobacco is increasingly being denied advertising air space, at least in the West, which means manufacturers are having to get inventive about how they put their products in front of their audiences. New platforms mean taking into consideration 'brand stretch', and that's where the designers come in.

As a test bed for a new-style tobacconist, Amsterdam is an apt location. But BAT's store 451°F is not just about cigarettes. This is more a homage to a lifestyle with references to all that is cool – and that includes smoking.

Fitch in London was tasked with creating an environment which would set off the BAT brands in a way that appealed to the target audience of fashion conscious youngsters. So this is more experience than retail, with music decks and coffee area, and plenty of sofas upstairs.

Customers are encouraged to chill out, lounge around and generally soak up the atmosphere, rather than just pick up a pack of 20 and rush out. This is taking the experience of smoking beyond smoking itself.

Graphics play an important role in setting the tone of the store. Fitch has taken its cues from BAT's flagship brand, Lucky Strike. Hence the deconstructed bull's eye that reaches from the ground floor to the first floor 'decompression zone'. The shelving, facia and in-store graphics are also in keeping with Luckies, as plenty of the signature red is used.

If all goes well, there are plans to roll out 451°F to other major European cities, and even Asia.

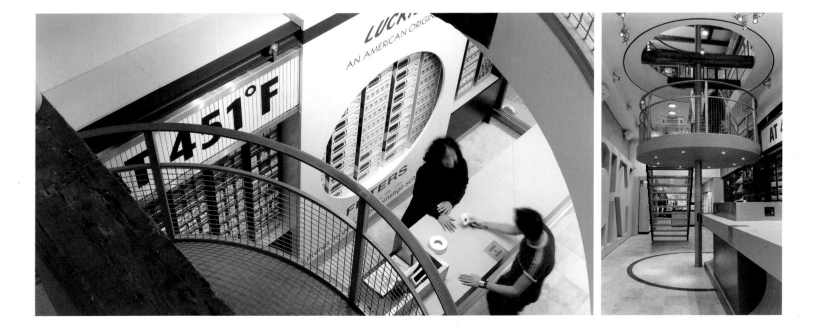

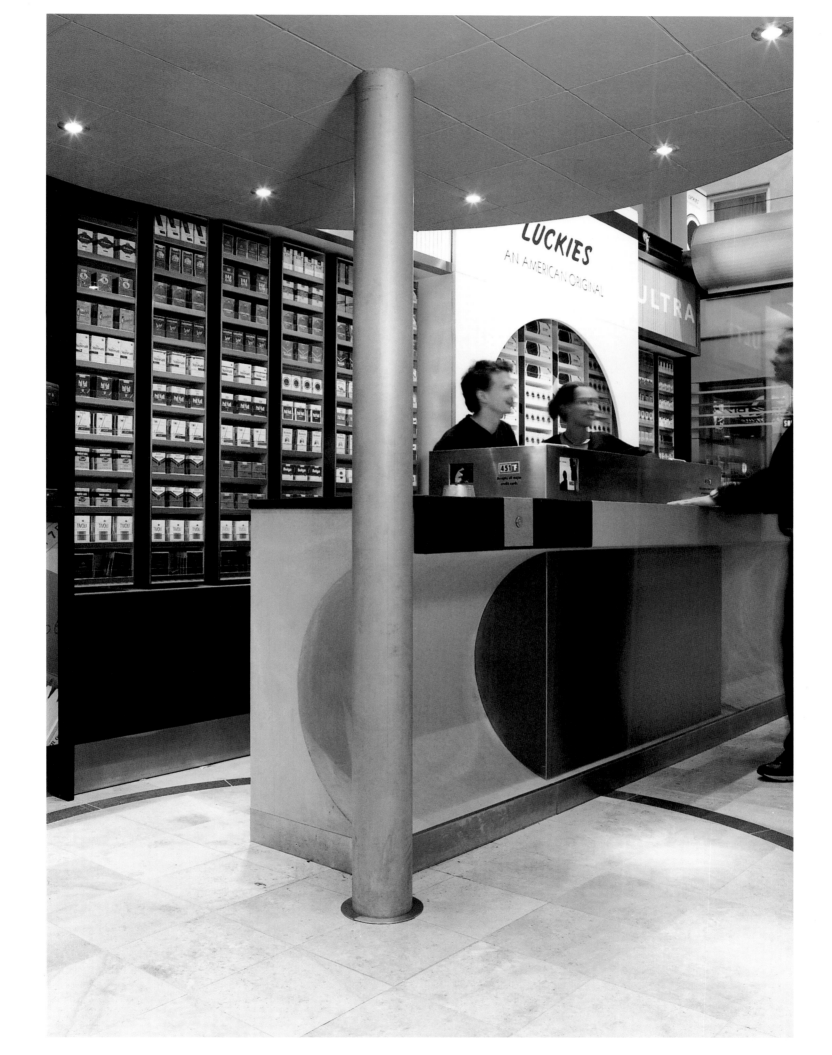

Below
The chill-out
area upstairs
at 451°F.

Opposite
The Lucky Strike
logo as seen
from the street.

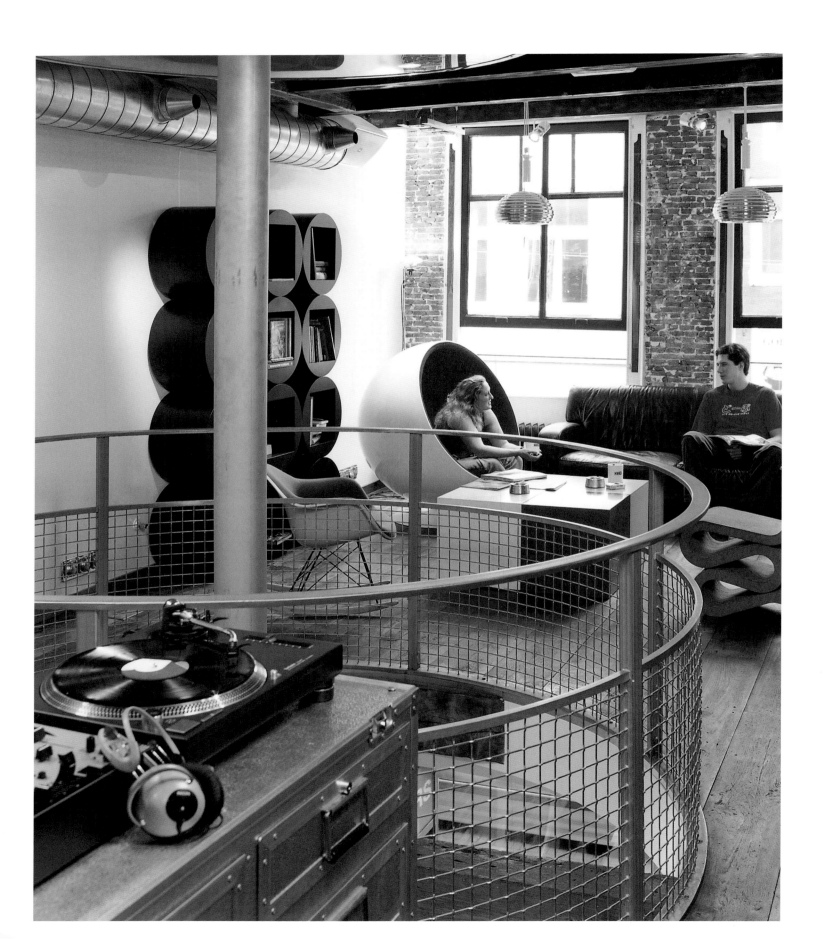

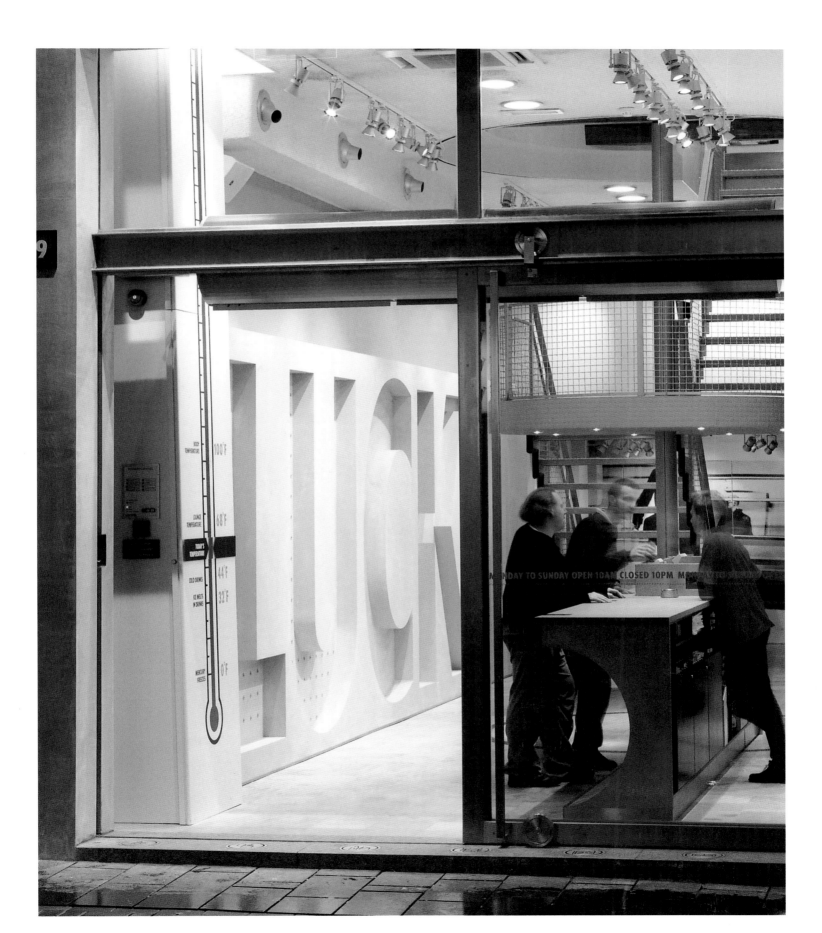

CASE STUDY
FORD FLEXIVITY

AN APPEAL
TO A YOUNGER
AUDIENCE

Ford Motor Company has set up shop in the Parkway Plaza Mall outside San Diego. Ford knew it had to extend its appeal to young customers, and ad campaigns alone were not doing the trick. Other car companies, like Jaguar, are trying their luck with the younger generation with new showrooms and ad campaigns combined, but Ford had other ideas.

The Flexivity retail environment taps into young people's love of customisation. The idea behind it is that for them, their car is like their first apartment. "They like to express their personality through unique accessorisation," Ford believes. The Flexivity concept takes vehicle customisation to a new level, believing that a car is more than a means of transport; it can also be a medium for personal expression.

Designed by Braga Oris Associates in New York, the interior layout of the 5,500 sq ft of store reflects that of an automobile assembly line. Instead of chassis stations, however, Flexivity features computer modules and music customisation kiosks.

The merchandise mix includes clothes and music products. Customisation can also be achieved with dye-your-own seat covers and airbrush equipment. The Flexivity identity, which has no obvious connection with that of Ford's, was designed by Upshot in Chicago. For both Braga Oris and Upshot, this was a case of taking Ford's values and reinterpreting them for a new audience.

"Flexivity continues to grow each month in terms of revenue," says Susan Venen-Bock at Ford. "We have met and exceeded our goal of attracting our target audience."

Opposite
Interior of Ford's
Flexivity shop
in San Diego
by Braga Oris
Associates.

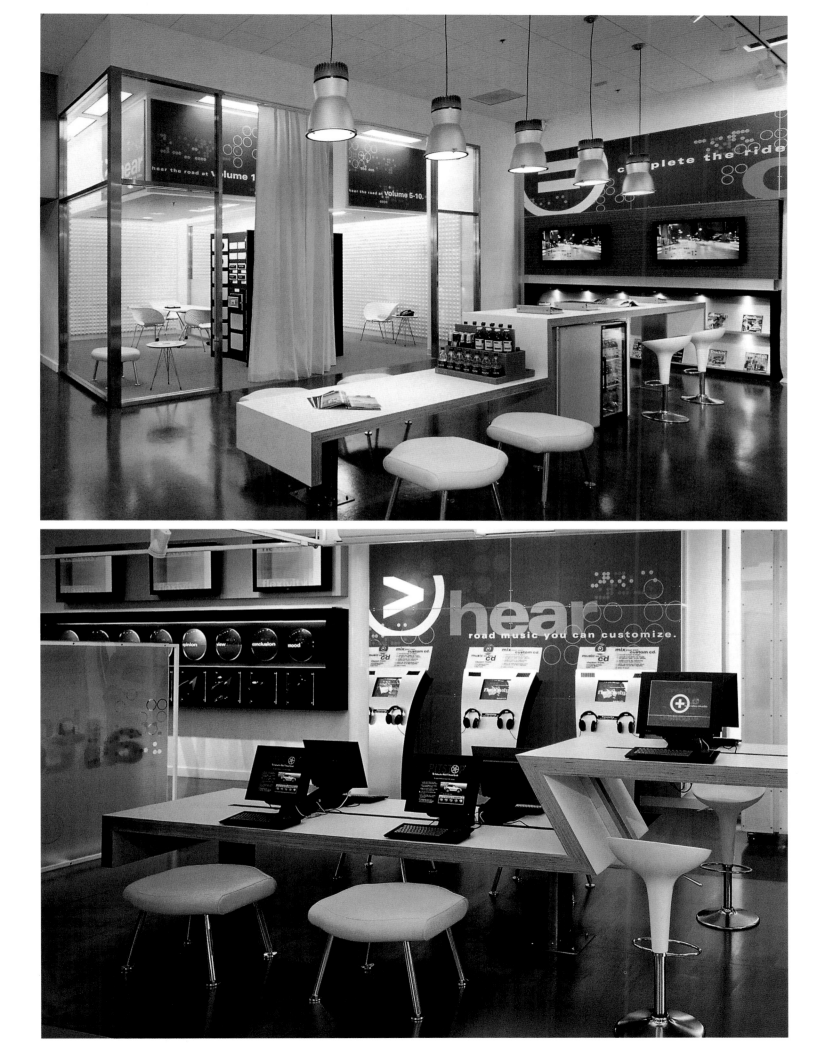

Right
The Ford Flexivity
store makes
reference to
an automatic
assembly line.

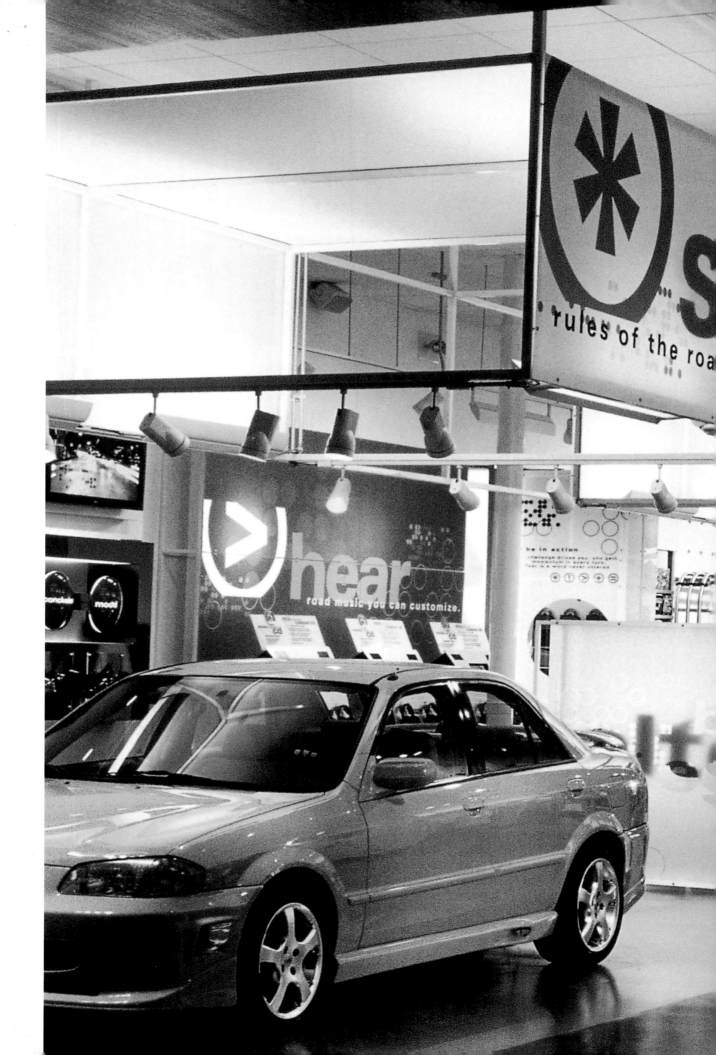

CASE STUDY
GUINNESS STOREHOUSE

MAKING THE BLACK STUFF TRENDY

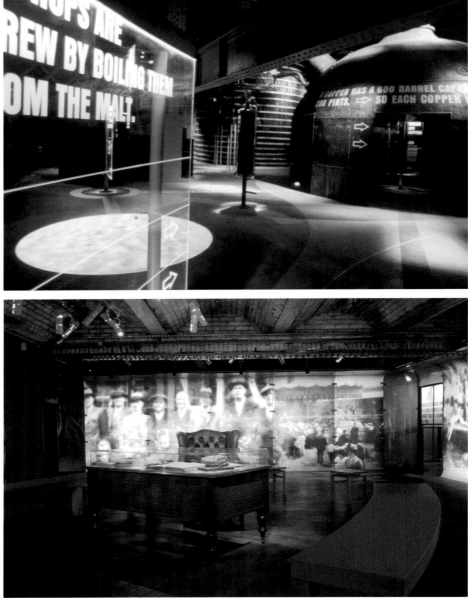

Guinness Storehouse is a 30 million pound experience, aimed at wooing young drinkers away from lager and cocktails and back to the black stuff.

The six-storey building, in Dublin's St James's Gate Brewery, houses gallery space, events venues, a visitor experience, restaurant, archive, training facilities and a public bar called Gravity located on top of the building with a 360-degree view.

This is an extraordinary 170,000 sq ft space, constructed around negative space in the shape of a pint glass which forms the central atrium. This makes the Gravity bar the 'head' of the pint.

When advertising has failed, and you're not responsible for the retail environments where your brand is sold, creating your own space is one way to regain some control over perception of your brand.

An environment like The Storehouse is more likely to change perception than boost sales. As Guinness marketing director Steve Langan put it: "It's got to change attitudes… By changing attitudes we change behaviour."

Opposite/Below
Imagination's
strong graphics
tell the Guinness
story.

Opposite
Guinness hopes
the Gravity bar
on the top floor
will become a
destination in
itself.

And an environment can also be a good way of targeting a specific audience – in Guinness's case fun young things of all nationalities who visit or live in Dublin. The brewer's previous museum, the Hop Store, had a visitor profile that was 26, single and European. The aim is to replicate this at the new venue. "We are seen as old Ireland so we need to reinvent ourselves for that audience... We don't want to get left behind," says Langan.

The building was designed by London-based firm Imagination with Dublin architects Robinson Keefe & Devane. It's designed around experience and interaction – two things that conventional marketing finds hard to deliver. "The name of the game is relationships," says Ralph Ardill, marketing director of Imagination, which also created Cadbury World Fantasy Factory. "And the best way to build relationships and change behaviour is through a shared experience."

"Brand experience can almost give brands a second chance. Established brands are looking at new ways to connect people with the more human sides of their business and what they stand for," he adds.

To create an experience which tallies with an FMCG, careful attention must be paid to existing brand values. Guinness was looking for a global home, based around the values of power, goodness and communion. "We believe Guinness is bigger than just being a beer," says Langan. This is epitomised in the way Imagination brought the values alive, through devices such as an impressive indoor waterfall, and the ruby lighting that illuminates the building exterior at night.

At its opening, back in autumn 2000, Guinness was hoping The Storehouse would get one million visitors a year in the first three years. According to research from Tourism Development International, 570,000 overseas visitors experienced the venue in its first year, making it Ireland's top tourist attraction.

CASE STUDY
VW AUTOSTADT

CARS AS A DESTINATION
IN THEMSELVES

Volkswagen Group opened its 850 million Deutschmarks Autostadt in summer 2000. It's a collection of pavilions, each for a different VW make, featuring restaurants and shops spread across 25 hectares at VW's mother plant in Wolfsburg. The objective was to attract and retain new sectors of the population as customers. "We are trying to reach customers and visitors through both a rational and emotional approach," says an Autostadt spokeswoman.

Each pavilion has taken a different approach to style and content, and attempts to exude the specific values of that make. VW's umbrella brand values of safety, social competence, quality and environmental responsibility are also represented.

UK design consultancy Furneaux Stewart created the pavilions for Bentley and VW. Nick Swallow of Furneaux Stewart says of the VW pavilion: "We tried to find a metaphor for their philosophy (the spirit of evolution), without using cars."

They came up with a film that runs in the cubed pavilion. It features two young sisters, one who is learning ice-skating and the other the violin. Swallow attempts to explain the metaphor: "Learning a skill is a series of small steps, and requires patience."

Autostadt is proving popular. The venue was expecting one million visitors a year, but had reached that target within six months of opening.

Below
Bentley's branded
pavilion by
Furneaux Stewart.

CASE STUDY
VIZZAVI

AUDIO BRANDING
FOR THE ONLINE
AGE

Vizzavi is a joint venture by Vodafone and Vivendi. It was set up in 2001 as a multi-access internet portal in Europe.

Identica created an identity which was intended to reflect the fast-changing nature of Vizzavi's business and provided a cohesive brand language for all its European markets.

Given its areas of operation, a visual identity was seen to need support from an audio counterpart. Audio branding firm Sonicbrand were brought in to translate Vizzavi's values into sound. "By approaching the brand from a musical perspective we were able to tap into everybody's innate musical sense and help discover how the brand truly made them feel," says Dan Jackson at Sonicbrand.

The company set out to create a sonic language that would communicate the essence of the brand and work across any audio medium.

So from telephone hold systems, exhibitions and corporate videos to TV commercials, an audio language has been developed. Sonicbrand started by creating a three-second logo, to be heard when the web portal is accessed. A longer piece of music, but still very much from the same family as the logo, was then created for the phones.

Ten tracks were composed in total, six of which each focused on a different Vizzavi value. For example, Vizzavi's social value was represented using a gospel choir, while 'corporate heritage with a contemporary edge' is illustrated through classical strings, bass sounds and synthesised 'pads'.

The audio branding has been particularly effective for internal audiences – that is call-centre staff. Vizzavi has a host of different sorts of calls to deal with, and no one version of the sound was going to suit every instance. So Sonicbrand came up with some music to suit customers on hold for the Pop Idol TV show line, and something completely different – and much more soothing – for the customer complaints on-hold sound. Since this music has been introduced, Vizzavi tele-operators have anecdotally reported a drop in the number of irate customers, which in turn has raised call-centre morale, according to Jackson. "Music really does change how people feel," he says.

Below
Logo and graphics
by Identica.

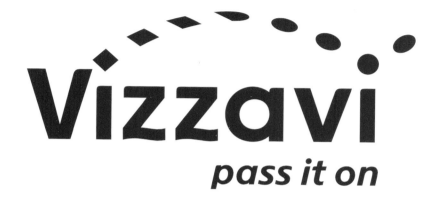

CASE STUDY
WELLBEING

A SHORT-LIVED
JOINT VENTURE
INTO BROADCAST

Boots and Granada Media joined forces in 2001 to launch an independent internet and broadband company which had ambitions to be Britain's leading e-business for health, beauty and well-being.

This had huge potential, they believed. Health and beauty are two of the world's largest growth markets. In the UK alone, and excluding the National Health Service, sales of health and beauty products and services amount to 11 billion pounds a year (according to Verdict research). In the end, the channel aired from March 2001 to the end of November of the same year, and folded with reported losses of 31 million pounds.

It was up to London graphics consultancy 4i to pull the branding off. It was the lead brand design consultancy for the creation of the network of TV and internet services, while London on-screen identity specialists English & Pockett handled the on-screen idents.

The brand had to work across a number of platforms, and had to be relevant to both partners. This 'challenge' was intensified by the two organisations' very different cultures. "It was a clash of cultures between an entertainment company and a high-street retailer," says Mark Norton of 4i. "One was interested in making programmes and the other was interested in selling goods online." But while "Boots is meticulous to the point of anal retention about its brand," according to Norton, "Granada is not a brand in the same way." Given that 4i had spent months working on the branding before Boots even signed up as partners, the discord that arose was perhaps inevitable.

Below
The combined
logo for the
Wellbeing TV
channel, designed
by 4i.

being

fitness

PRODUCT DESIGN
AS EXPERIENCE

With increased focus on branding come all the trappings of marketing communications. So when London product design company Factory was commissioned, with Conran & Partners, to design the interiors for the new Concorde, it was given a description of the Concorde customer. In terms of audience profile, Concorde passengers are one of the easiest to define in the airline industry – as captains of industry. "Normal business class is filled with a bigger mix of people. That affects how you define a brand and the atmosphere of the plane," says Adam White at Factory.

This was a case of product design creating an experience, while exuding the appropriate brand values – service and quality – three-dimensionally. Factory started by looking at environments which would be familiar to the typical Concorde customer – for example the interior of the new Aston Martin, or the washroom of Philippe Starck's London hotel, St Martin's Lane.

Then the brand values had to match up to the on-flight experience. These, according to Paul Wylde, the brand guardian of British Airways' Concorde, are British, insightful, innovation, quality and reassurance. On top of those, Factory and Conran & Partners had to take into account the brand's characteristics: intelligence, humour, confident, professional and contemporary classic. "I wanted people to know they were having a BA Concorde experience even when they were covering up the logos," says Wylde.

The result was Connolly leather on the furnishings, linen-cotton mix napkins and lots of blue – courtesy of Conran & Partners.

Although this was genuinely a 'beyond logo' brief, Factory played a clever game with the BA speed marque designed by the then Newell and Sorrell. "Though it's always drawn flat, it is in fact three-dimensional. We thought we could do something with that," says White. And so they incorporated it into the seats. "It was obvious that the marque would carry the arm rest beautifully." While not every passenger is going to catch on to this ingenious bit of branding, "those who see it get closer to the company," believes White. Again, subtle branding helps reinforce a sense of ownership in the consumer.

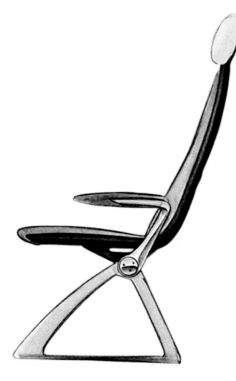

Left
An early rendition by Factory of the Concorde chair designs.

BRITISH AIRWAYS

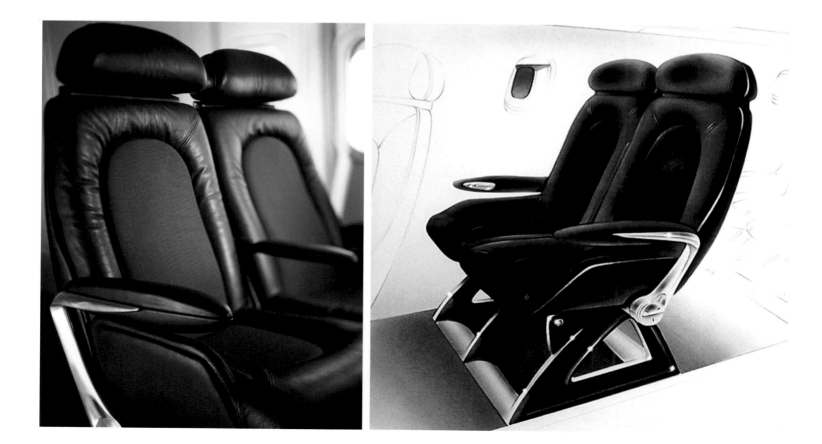

INJECTING A
PERSONALITY
INTO A BRAND

How do you take a technology-focused company and encourage consumerist tendencies to reinvigorate the brand? That's the question Tim Parsey posed to himself when he took on his current job. Parsey is head of consumer experience design for the personal communications sector at Motorola. In other words, he's responsible for the look of the company's phones. Motorola feels, rightly, that it has missed out to the likes of Nokia in Finland, and it needs to take branding on board. In 2001, Nokia had 35 percent of the world market, and Motorola was a distant second at 14 percent. Parsey's task is to take the values of Motorola, impart them to a re-enthused team of designers around the world, and get them instilled in every new product.

This brief has the potential, at least, to go way beyond Motorola's distinctive batwing logo. "We're looking to build a cohesive story so that there is recognition (of the Motorola handsets) for the first time," he says. No mean feat for an organisation that for decades has been steered by the engineering departments. "Before, design was a service to engineering. But engineering now has to be connected to culture," Parsey says. This 'Motorolaness' for Parsey is about rich minimalism, creating hardware and digital interfaces which live up to this quality. But this doesn't just refer to the style of the phones. Numbers are being cut too. There were 96 phones when Parsey joined in October 1999. In 2002 there were just ten.

"Design has to be the competitive weapon," believes Parsey, who spent five years at Apple in the 1990s. He's been drawing his new troops from the design departments of Swatch, Philips, Sony and the Domus Academy in Italy. From his base in Chicago, he manages Motorola's design centres around the world.

Phones can be customised to carry the branding of different carriers. Of course this carries the risk of diluting the Motorola brand, which is why the look of the product needs to be cohesive and unique. Packaging and web design have also been adapted accordingly, to complement the newly instilled 'Motorolaness' of the phones. One of the first manifestations of Parsey's appointment is the swivel handset which launched in 2002.

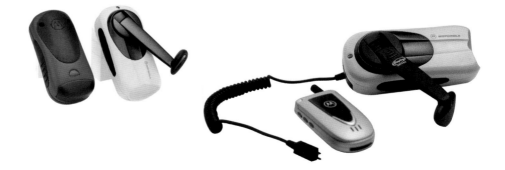

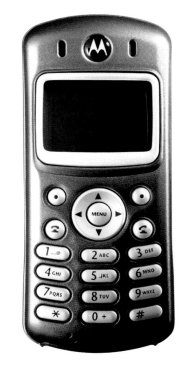

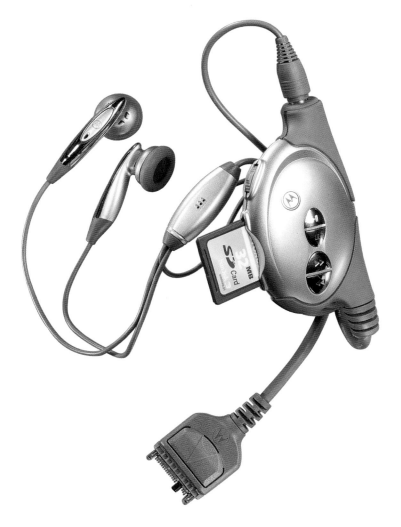

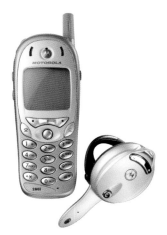

Opposite/Above/
Overleaf
New products
expressing
'Motorolaness',
for which Parsey
was responsible.

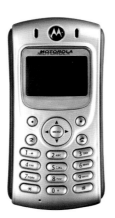

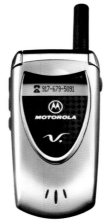
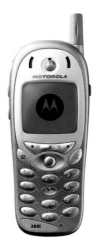

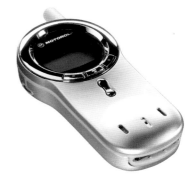

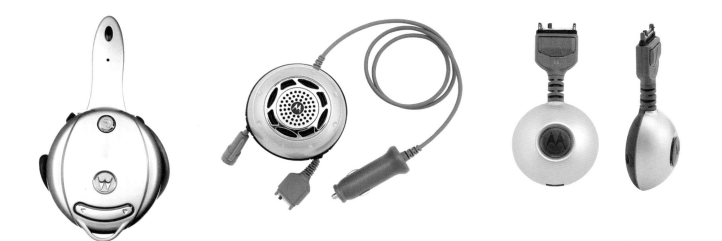

CASE STUDY
AUDI

BRANDING
THROUGH
ITS PARTS

According to Audi, the marriage of form and function is the philosophy that is its very lifeblood. Its design-led approach is what sets it apart from its peers, Audi believes. This can be a tricky USP to articulate, however, especially if you are a sales executive working out of a provincial dealership. And the average punter needs the message strengthened, too.

"We're trying to get dealers to talk about design confidently," says Audi UK's head of marketing Rawdon Glover, who admits, "it's proving to be a hurdle to get them to embrace design." To impart its design credentials to these showroom staff and potential customers, Audi had gone down all the usual routes like advertising and direct mail, then they decided to try something different. "We wanted to bring the brand alive in a three-dimensional way," says Glover.

Glover brought in London product ideas people Jam and briefed them to bring design alive in the Audi showrooms. Jam was given a free rein. "We had no idea where it was going to go," Glover says. Like any conventional brand consultancy, Jam went on a fact-finding mission to investigate the brand.

This included trips to the factories in Neckarsulm and Ingolstadt in Germany, meetings with Audi's marketing team and external creative agencies and visits to the training school and showrooms. The result is a range of furniture and installations fashioned from Audi vehicle parts. It may sound tacky, but they get away with it.

Hence the Audi A4 rear spring which doubles as a magazine rack; the suspended light installation created out of dipsticks (and dipsticks from the A2 vehicle, no less, which are extra long as the bonnet doesn't open on this model); a series of wall-mounted speedometers from the A4, which are linked up to some clever sensor technology and react when someone passes them; two chairs made of aluminium (Audi's favourite material) with seats formed from woven car seatbelts; a bench and coffee table featuring the TT roll bar; the A4's head gaskets turned into a bottle rack; and a toilet-roll holder which started life as a wing mirror. Plans are on hold for a water feature: a fountain that drips water every 30 seconds to create the Audi logo.

The pieces went into the Audi Forum, which opened in London's Piccadilly in February 2002. Designed by Teark – the architectural practice affiliated to Stockholm Design Lab in Sweden, Glover describes the forum as being halfway between a dealership and an experience. Audi is setting up these sites all over its territories, and London follows Munich, New York, Tokyo, Stockholm and Berlin. The plan is to have a forum in every key city. Through them, Audi hopes to raise awareness of its brand and product, and through the installations, the role that design plays in the organisation is highlighted. At least that's the idea. If the pieces actually capture the public's imagination, they could go into production to be sold. Though as Glover says, that was not the original objective.

As Jamie Anley at Jam says, "If the public starts buying pieces which started off as forms of communication, that's when Audi becomes a lifestyle brand." This has the potential to be merchandise with a difference.

As for the UK's 120 dealers, each is expected to carry a handful of Jam's pieces, to inspire staff when they are eulogising over Audi's superior design credentials.

Right
Jam turns Audi's
petrol caps into wall
lights and creates
an illuminated
dipstick installation.

Below
Jam upholstered
these chairs with
car seat belts.

Opposite
Stockholm
Design Lab's
experiential
environment.

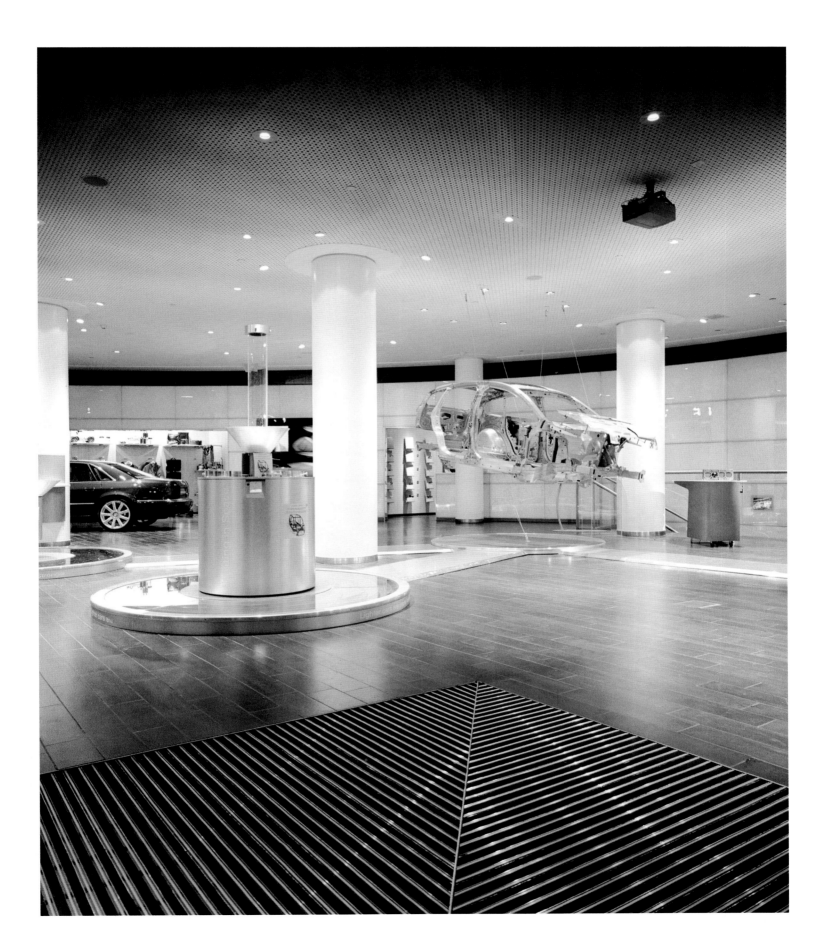

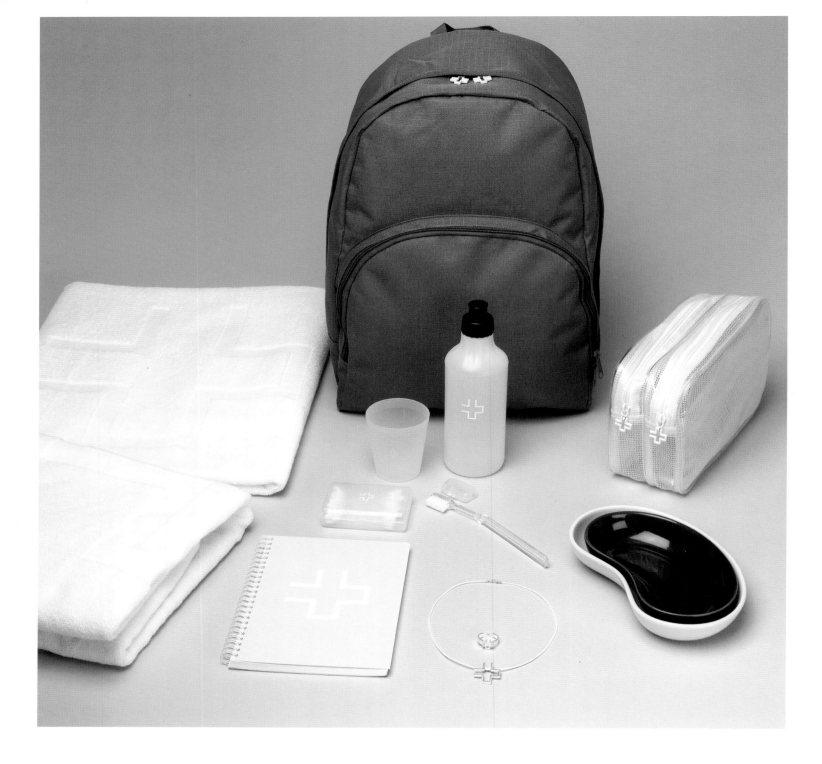

Above/Opposite
Stockholm
Design Lab got
involved with
every element
of merchandise
for the Swedish
nurses' union.

The Swedish Association of Health Professionals is the union for 93 percent of the country's nurses, midwives and biomedical scientists and has more than 110,000 members.

Sweden's highest profile design consultancy Stockholm Design Lab came up with an open-ended cross as the union's new identity; but that was just the beginning of the project.

Through trade fairs, meetings and other events, the union gives away a plethora of merchandising items every year. Rather than just applying the new marque to the existing gifts, the union asked the consultancy to design a complete range of products. These range from sponge bags and knapsacks to jewellery. The use of the identity is kept to a minimum, for example as zip tags on the bags. "Where you might expect there to be a marque, we've expressed it in a different way," says Thomas Eriksson. And because the graphic branding is so minimal, a sense of ownership is generated. "If you give this ring to someone it becomes theirs, and is no longer the organisation's," he adds.

CASE STUDY
VÅRDFÖRBUNDET

MERCHANDISE THAT IS ON MESSAGE

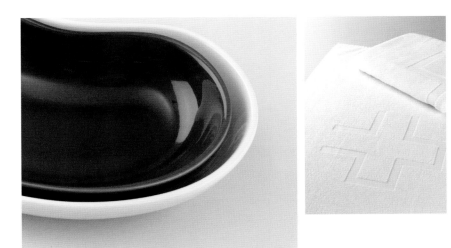

CHAPTER 2
THE GUARDIANS

MANCHESTER UNITED
ALLIED DOMECQ
POST OFFICE
ALPHARMA

THE GUARDIANS

MERGERS AND ACQUISITIONS, DEREGULATION AND THE MUSHROOMING OF DOTCOMS ALL HELPED LINE THE BRAND CONSULTANCIES' POCKETS IN THE 1980S AND 1990S.

THESE PHENOMENA FUELLED THE INCREASE IN MAJOR CORPORATE BRANDING JOBS, FROM THE FOUNDING OF TELECOMM ORANGE IN THE UK TO THE MERGER OF TIME AND AOL IN THE US.

To make the most of the boom times, the corporate branding consultancies repositioned and restructured to cater better for such massive projects. Hence the influx of client-side consultants and MBA strategic thinkers into what were once design studios. Design in some cases took a back seat, as the big earners – strategy and consultancy – got given a higher and higher profile.

However, times have changed, and the consultancies are feeling it. The heyday of deregulation is over, the dotcom bubble has burst, and in the economic climate of the new century, the bottom has fallen out of the mergers and acquisitions (M&A) market. Add to this a cynicism among the public and media for what are perceived as unnecessary or botched name or identity changes, and the clients' reluctance to commit to big budget change is understandable. "The repositioning of BA and its new tailfins certainly set radical change back a bit," says Kate Ancketill of UK design advisory service GDR.

"There are fewer major rebrands because of the lower budgets," adds John Mathers at Fitch:London. "People are spending their money more wisely and they realise that (in the past) they threw the baby out with the bath water."

For clients who have been disillusioned in the past, a lower key approach to branding must seem like a safer, and cheaper, option. There are still some major brand creation jobs out there, but the consultancies are having to rely increasingly on a different type of project for their bread and butter: brand guardianship.

Typically, these jobs demand no major change in direction for the client, and hence no spanking new logo. This is about look and feel, maintenance of a client's visual manifestation to keep it fresh and relevant. So literature, advertising, websites and such like will change, around a fundamentally unchanged marque.

This is what London group Springetts carried out for football club Manchester United, what Enterprise IG did for BT, what Landor did for Norwegian pharmaceuticals outfit Alpharma, and what SiegelGale has done for Dow and Motorola in the US.

Sometimes, the visual manifestation needs to say something quite new, as was the case with the brewer Allied Domecq, and the Post Office, both in the UK. Both companies' managements were happy with the logo, but wanted to change perceptions through everything else. For this Allied Domecq went back to their identity designers, Design House, and the Post Office brought in design firm Marketplace.

It's not always a case of designers being restrained from getting their hands on the logo. Sometimes a consultancy will actually advise against messing with the marque. Marksteen Adamson at Interbrand suggests something as well-crafted as the UPS logo could and should be left well alone.

FOR CLIENTS WHO HAVE BEEN DISILLUSIONED IN THE PAST, A LOWER KEY APPROACH TO BRANDING MUST SEEM LIKE A SAFER, AND CHEAPER, OPTION.

Fitch advised Hush Puppies not to lose the dog from its branding, although the client was initially keen to get rid of it. "We told them it's the stuff that surrounds it that needs to change," says Mathers.

Brand guardianship certainly plays an important, if less sexy, role in a brand's life. In the old days, a brand was likely to be owned by, or in the control of, the ad agency. But advertising accounts move and another agency then gets to interpret the brand anew. This can lead to confusion and inconsistency, as there is no single source of "-ness", or "brand personality", says Peter Knapp at Landor in London.

Brand consultancies believe they are much better equipped to look after a client's brand. This role of guardianship includes brand architecture, (that is, how its services, products and such like are arranged); plus graphic presentation for external and internal audiences, the website, corporate communications, working with the ad agencies on tonality, direct marketing; and the three-dimensional world, such as showrooms or airport lounges, exhibition stands and reception areas.

In the past, brand guardianship had become synonymous with uniformity – adhering to tight design guidelines at all times, with heavy use of the logo itself. But being slaves to consistency is no way to keep communications fresh. In fact consistency alone is seen as rather old hat. "A while ago the mantra was consistency, but that's rather boring and the audience has matured beyond it," says Knapp. "It doesn't hold their attention."

Instead, the focus has shifted onto developing recognition and ownership, and as Knapp says, "that's about capturing the tonality of the experience".

A consistent reproduction of a logo is more likely to turn a consumer off than on these days. Many of us are less rather than more enamoured by a company that expects us to act as mobile billboards, advertise their marque for them on everything we carry.

Stockholm Design Lab disapproves of this approach. "People have been violated by overexposure to marques," says Göran Lagerström at SDL. He cites the airline industry as being particularly guilty of this overexposure: "The average airline has more than 3,000 items, and most have the logo on them."

This is in some respects the more challenging end of brand manifestation. How to create differentiation for a client whose brand values are similar if not exactly the same as its competitors? All companies, it seems, want to be innovative and caring, dynamic and responsible. So it is only the most imaginative designer who can really get to the root of a company's personality and express that effectively through the look and feel. "Companies sometimes have similar values but the combination of values and the interpretation and definition of positioning can be different," says Nick Moon at FutureBrand.

So brand guardianship is about maintaining freshness, appreciating the mindset of the logo-weary consumer and, hardest of all, creating differentiation in increasingly crowded marketplaces.

MANY OF US ARE LESS RATHER THAN MORE ENAMOURED BY A COMPANY THAT EXPECTS US TO ACT AS MOBILE BILLBOARDS, ADVERTISING THEIR MARQUE FOR THEM ON EVERYTHING WE CARRY.

Below left
Springetts' new
Manchester
United ticket.

Below right
One of Design
House's brand
guidelines for the
brewery Allied
Domecq.

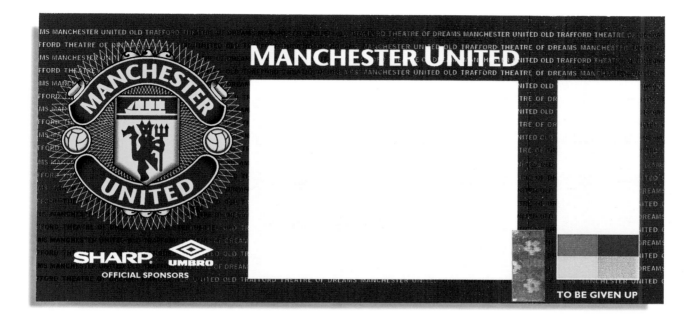

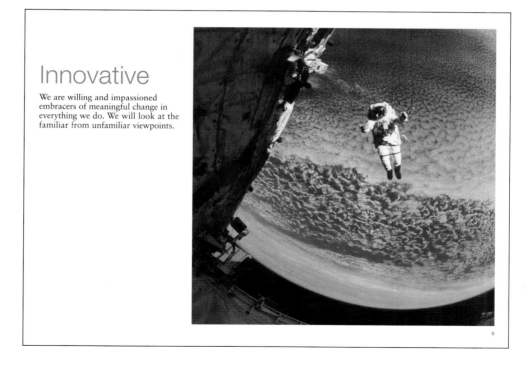

Innovative

We are willing and impassioned embracers of meaningful change in everything we do. We will look at the familiar from unfamiliar viewpoints.

9

Below
Springetts' new, tidier
signage for the club.

Opposite
Manchester United
Football Club's old
signage.

CASE STUDY
MANCHESTER UNITED

FROM A FOOTBALL CLUB
TO A MULTI-FACETED
INTERNATIONAL BUSINESS

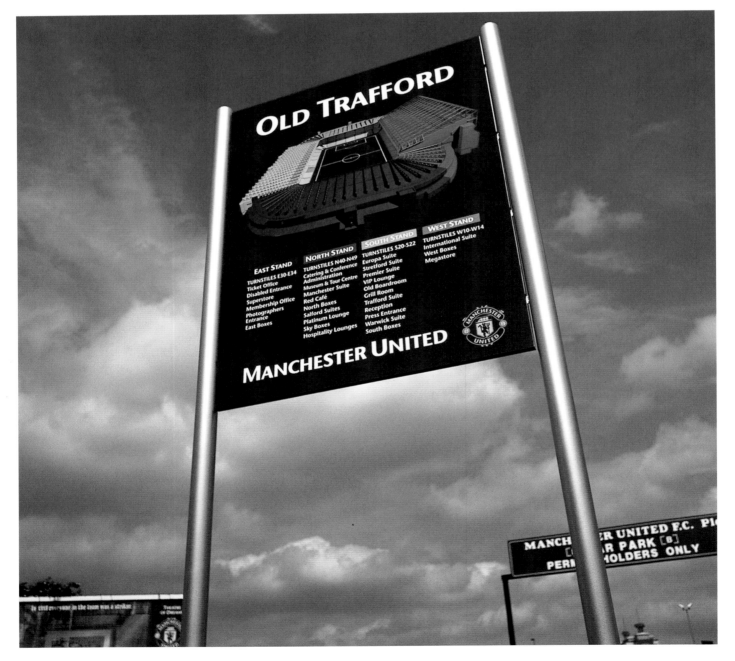

Manchester United used to just signify football club. That was in the days before the organisation saw its true potential as an international leisure business. But in order to realise these ambitions, the club needed a positioning and brand architecture to accommodate them. Of course it had always had experience at the heart of the business, but at the time, this was just the experience of football. Manchester United saw potential for its Red Café at the Old Trafford ground to be licensed worldwide, and for its interests in retail, conference, catering and media to also be developed.

Manchester United has an estimated ten million fans in the UK alone, with countless others as far flung as Thailand and Argentina. It is also the richest club in the world, with a turnover in 2000/01 of 130 million pounds. Diversification of the club's business concerns has been at the heart of this success.

London brand consultancy Springetts got their hands on the project, and like all good consultancies, began with an audit of the club's existing branding. Manchester United Football Club showed all the usual hallmarks of a neglected brand – disparate renditions of the identity across the seemingly endless executions on stationery, signage, the magazine, tickets, the shop, mail order catalogue, website, museum. "We looked like a mini conglomerate rather than one beast," says Manchester United marketing director Peter Draper. This was confusing for staff and it meant that fans (consumers) were getting mixed messages.

At the same time, the club was lining up more international marketing opportunities with other 'big name' brands, thereby potentially muddying the water even more with those extra graphics.

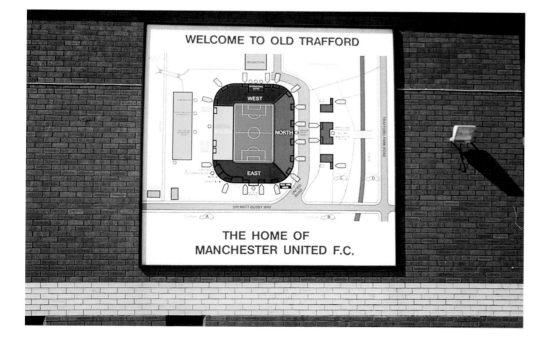

Springetts' identity guidelines were drawn up with two purposes in mind: to control the extension of its football business into markets far beyond its north-west UK roots, as well as into other business sectors; and to engender vital internal co-operation and motivation behind the brand as one single offer.

A big step forward in the rebranding was the dropping of the words 'football club' from the name. Although potentially controversial, Springetts convinced the client of the move, saying as far as Manchester United was concerned, the descriptor was redundant. It also gave the brand increased flexibility when moving into new areas.

In terms of the logo, this was evolution rather than revolution. Springetts' revamp was intended to add depth, richness and drama to what had been a flat image. The consultancy then created a bespoke typeface for the organisation.

The entire project was about a thorough tidying up, to help an organisation better express itself. "It's made us more professional in front of our fans and in business-to-business," says Draper.

Opposite
Before Springetts introduced a single alternative (above), the club was using a plethora of logos (below).

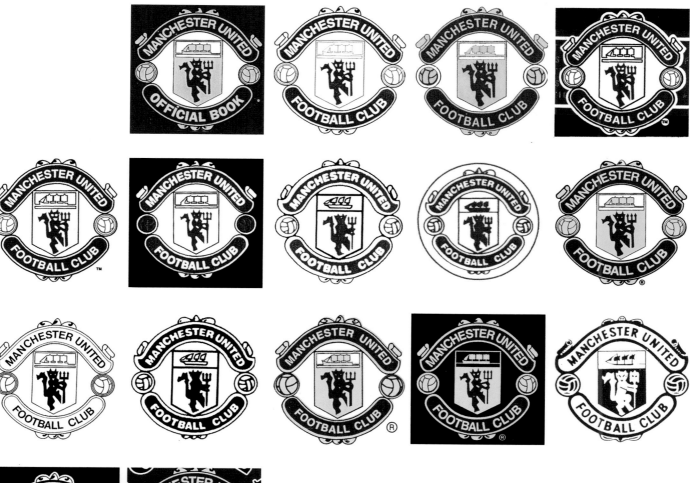

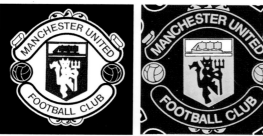

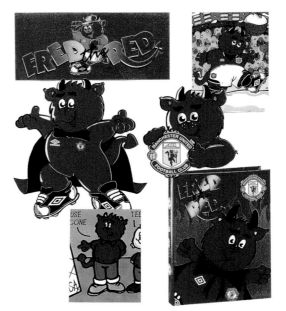

It was a job that took in everything: the mail order catalogue, café, museum, children's mascot Fred the Red (who got his own logotype and set of design guidelines, and six new standard poses), stationery, ticketing, signage, team kit, merchandise, promotional material for potential sponsors, on-screen usage for TV, magazine and all licensed material. Now there are Red Cafés in Kuala Lumpur, Singapore and Dublin, and stand-alone stores from Thailand to the UK. And when the financial services sub-brand, MU Finance, was launched in October 2001, Springetts created an identity that was in keeping with the master brand.

Before, Manchester United comprised three separate operations: the football club, retail and merchandising, and conference and catering. Now, all three come under one brand, and audiences as diverse as sponsors, suppliers, analysts, competitors and fans should appreciate the difference.

NEW VALUES FOR AN EXISTING IDENTITY

Sometimes it doesn't matter how good an identity design is, as if it's not looked after it can affect a company's image. Allied Domecq's identity drifted into trouble, at the same time that the business was struggling. The drinks company's new management spotted this the minute they took over in the late 1990s. The identity had been created by Design House several years earlier, and the management were all for throwing the identity out and starting again.

However, when director of corporate affairs Jane Mussared met up with Design House (as part of the process of meeting all the company's current suppliers), she came to think otherwise.

Design House explained that their identity had suffered from years of abuse. Design guidelines had been blatantly ignored, and different internal departments were reproducing the copper and nickel marque in the wrong colour combinations. "People were just using the copper everywhere, and everything looked the same. It was expensive to print and just damn ugly. It was a mess," Mussared remembers.

The new management had been tempted not only to axe the identity, but to change the name too. "It had serious negative baggage, and the company was falling apart internally. Analysts said we needed to change the name." However, there was neither the time, energy nor money for such a drastic course of action, and Mussared recognised that the identity was well designed, it just needed to be made to work properly.

Allied Domecq's management had done some work on a new positioning, and had drawn up a statement of intent. From this, they worked out the values with Design House. These were defined as: competitive, challenging, daring, innovative, demanding, rigorous and passionate.

It was then up to Design House to draw up new guidelines around these values. The aim was to simplify the visual identity and thereby amplify its effect. This was to go across stationery, literature, presentations, website, signage and advertising. Details such as written style – expressing things in the active rather than in the passive as before – were also included.

"Our refreshed identity has a strong emotional element," reads Allied Domecq's material on the brand refreshment exercise. "It will send out powerful messages about who we are and what we stand for."

The refreshment had a major task to do if it was going to counter the company's old, negative image. The new Allied Domecq is intended to be strong, forward-looking and confident. And according to Mussared, it's worked: "As the values changed, there was a total culture change."

Opposite/Below
Allied Domecq's
logo, and details
of Design House's
brand guidelines
for the brewery.

Passionate

Our commitment is total. We never,
ever rest on our laurels. We have an
outrageous obsession with achievement.

12

Competitive

We will become the best by being
relentless, refusing to settle for second
best and being as tough on ourselves
as we are on our competitors.

6

CASE STUDY
POST OFFICE

MAKING ITS DEBUT
AS A CONSUMER
BRAND

Until very recently, the British Post Office did not think of itself as a brand. But as the threat of real competition started to become a reality, and as its customer base grew older and older, the business realised that it needed to behave as a modern, commercial operation, and that would involve thinking as a brand.

Deborah Maxwell joined in 2000 as head of brand, and was handed a budget of 400,000 pounds. Previously at The Woolwich Building Society and the AA, she was brought in to change the Post Office from being supply-driven to consumer-facing. Traditionally, the Post Office's customers aren't there voluntarily, but because they think it's the only place with those services. "We call our customers hostages because they think there's no choice, but there is," says Maxwell.

In the following months she put together her brand armoury, and got her total budget upped to 15 million pounds in the process. She first brought in research company Brand Finance to calculate the value of the brand, so that it could be leveraged for royalty rights in partnership deals. She then got talking to agencies about the role of brand guardian. Oxfordshire design consultancy Marketplace won the job, after beating off competition from Enterprise IG, Dragon (who had created the name and identity for Consignia, the Post Office's parent company), and ad agencies Publicis, McCann Erickson and Joshua.

It was now up to Marketplace to help Maxwell's team define the brand and to then define the way the Post Office communicated with its various audiences.

Marketplace started with defining the Post Office's values, as helpful, easy, knowledgeable and personal. The strength of these values was measured by research agency Millward Brown. The final list of values was broken down so that the Post Office now has four different brand values for each audience, from consumer, business, employee and stakeholder. For example, to the consumer the values are easy, personal, knowledge-able and helpful; and to the employee they are purposeful, flair, inclusive and accountable. It may sound rather dry and bland, but it's a start. And according to some before and after research on brand perception, things are looking up.

These values were briefed down to Publicis and Joshua – both appointed in March 2001 – to come up with above-the-line (TV) and below-the-line (other forms of advertising) campaigns respectively. The Post Office TV commercials last year featuring entrepreneur Richard Branson and Stelios of the Easyjet airline company were some of the fruits of this process.

Below
The old post office logo (left) was given the 3D treatment by Marketplace (right).

Amid all this activity, Marketplace reworked the logo, making it three-dimensional. Maxwell readily admits that if she had gone to the board saying she was going to redesign the logo, there could have been uproar. But the new version was a minor part of the overall repositioning, and hence almost went unnoticed.

So far repositioning through advertising and communications seems to be working. Since the new communications went live, brand perceptions have improved beyond Maxwell's wildest dreams. "I have beaten my five-year goals in one go," she says. Findings from Millward Brown show that the consumer values of easy, personal, knowledgeable and helpful were already well received in October 2000. However, consumers gave these attributes even higher scores in 2001, making the Post Office the UK's most trusted brand, bar the supermarket chain Tesco.

Right/Opposite
Old in-store literature relied heavily on puns (right) in contrast to the new approach (opposite).

ONE BILL YOU CAN'T PAY AT THE POST OFFICE.

FROM CATALOGUES TO COUNCIL TAX YOU CAN PAY IT AT THE POST OFFICE.

Ask at the counter for details.

Pay nthing for your foreign currency.

0% commission —
on any amount.
All year round.

What a good idea.

For more information ask one of our staff.
www.postoffice.co.uk

PM202A4

This excludes Sterling travellers cheques.

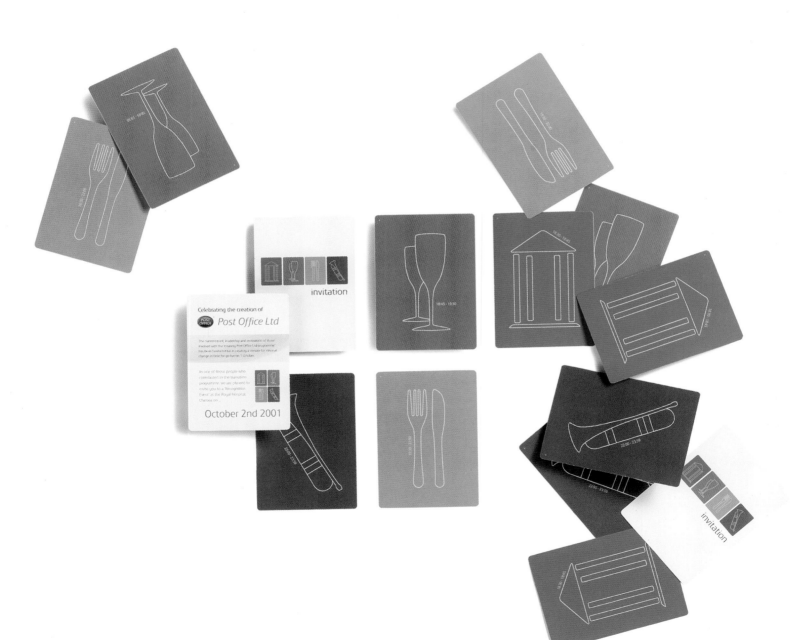

Below
Stationery is
given some
much needed
consistency.

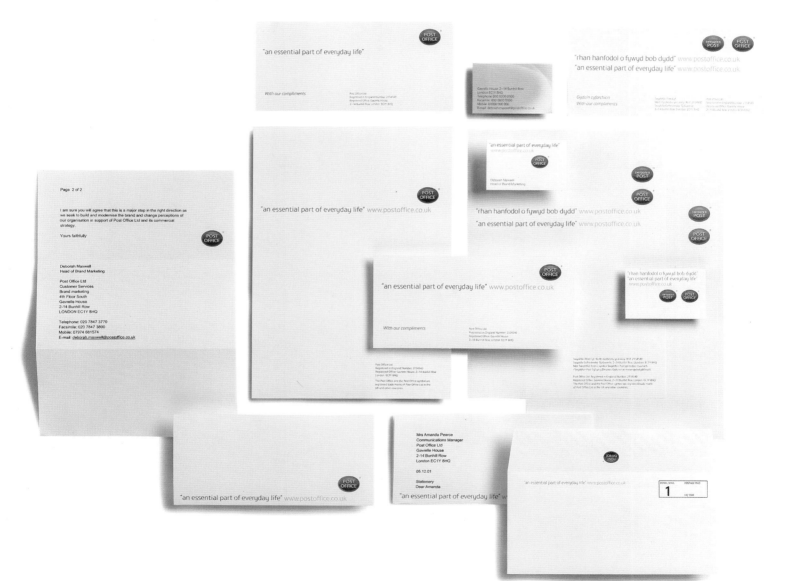

Alpharma suffered from the branding issues typical of many modern pharmaceuticals businesses. A succession of mergers and acquisitions had left it with a large, disparate portfolio of products. What branding there was tended to be inherited from the bought companies, and Alpharma's audiences were understandably unclear about the true provenance of many products.

The Norwegian organisation, which is listed on the US stock exchange, brought Landor in to tackle one of its three arms – human pharmaceuticals – to get its branding, packaging and communications in order. "They wanted to become one brand, with one look and feel," says Pippa Knight of Landor. The original brief was to "make us one company", but there were no details. This was a case of providing everything but the logo.

That's not to say that Landor would not have happily carried out a bigger identity change. In fact a name change (of sorts) was mooted – from Alpharma to Allpharma – but the cost of doing this in legal fees and time made it unviable.

But this wasn't just about tidying up for the benefit of staff and customers. According to Knight, it was an opportunity to change the perception of the pharmaceuticals market.

Following interviews with employees and business partners such as pharmacists and wholesalers, Alpharma's values were defined as open, brave and demystifying. Landor then came up with the pithy catchphrase: accessible medicine. For the first time, at Landor's suggestion, Alpharma started thinking of itself as a business-to-consumer rather than a business-to-business organisation. That meant taking into account the pester power of the patients.

CASE STUDY
ALPHARMA

GIVING DISPARATE
ELEMENTS A
SINGLE LOOK

Opposite/Overleaf
Landor brought
all Alpharma's
packaging under
one graphic style.

It also meant thinking about which audiences were going to be in contact with which elements of the organisation. So for the end consumer it was the packaging and website, while pharmacists and wholesalers, neither of whom see the packaging, were exposed to digital presentations and exhibitions, brochures and literature. Staff, on the other hand, see environments, signage, recruitment ads and training communication. Of course, there are areas of overlap like press coverage, ads, sponsorship and call centres, which all audiences experience to a greater or lesser degree.

In terms of design, all 3,000 pieces of existing packaging got a thorough going over, and a tight new system themed around a graphic representation of the pain barrier was put in place. Design guidelines were also created for literature, which included a photographic style with a reportage flavour. Landor then designed the look and feel of the website, for which the logo's typeface was tweaked, and created a box for employees called 'Get involved', which explained all the changes.

The consultancy then ran a pitching scheme for an ad agency, briefing contestants on style and language. The account was handed to Cobra in Oslo.

And it needn't have ended there. "We did an audit of signage in reception areas, and of exhibition stands, but they ran out of budget," says Knight.

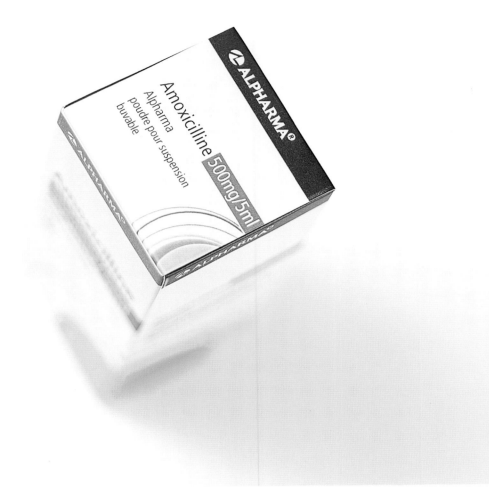

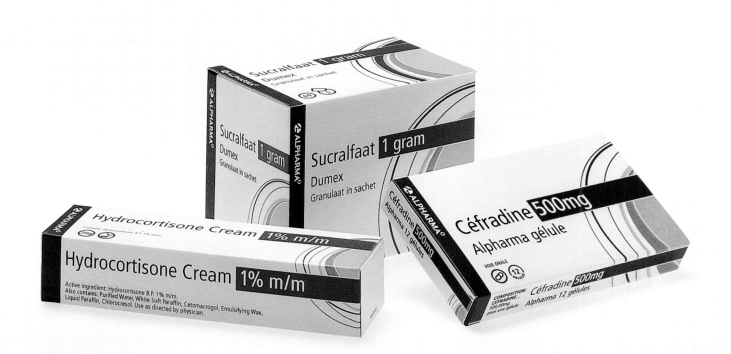

CHAPTER 3
NEW AMBASSADORS

ISH
US AIR FORCE
HONG KONG POST

ISH
TURNING PUBLIC SERVICE
STAFF INTO BRAND
WARRIORS

US AIR FORCE
ISSUES OF STAFF
RETENTION
TACKLED THROUGH IMAGE

HONG KONG POST
KEEPING WORKERS ON
BOARD THROUGH CHANGE

NEW AMBASSADORS

THE MODERN BRANDING WORLD
IS ONE WHERE BRAND VALUES
HAVE TO WORK HARDER ACROSS
MORE PLATFORMS –
FROM EXPERIENTIAL RETAIL
ENVIRONMENTS TO BESPOKE
ONLINE OR TV CHANNELS –
WITH THE POTENTIAL TO EXTEND
INTO NEW AREAS OF BUSINESS.

CLIENTS ARE LESS AND LESS
LIKELY TO VIEW ANY ONE PART
OF THEIR COMMUNICATION
IN ISOLATION. SO THE ANNUAL
REPORT OR THE CALL CENTRE
COULD WELL BE EXPECTED TO
FOLLOW THE SAME BRAND
VALUES, AS DEVISED BY THE
BRAND CONSULTANCY OR THE
INTERNAL MARKETING TEAM.

STAFF ARE NOW BEING TREATED AS BRAND AMBASSADORS – INDIVIDUALS WHO, IF THEY PERFORM APPROPRIATELY, CAN GIVE THE RIGHT IMPRESSION FOR THE BRAND.

Just as business has fragmented, so have audiences. Marketing departments are increasingly proficient at subdividing customer groups and then targeting them accordingly. The blanket mail shot addressed to 'Dear Sir/Madam' is virtually a thing of the past.

But for smart businesses, the consumer is now just one of the valued audiences for its brand. There have always been shareholders, who along with the analysts, are addressed through annual and interim reports, corporate events and strategically placed press coverage. Now the focus is on that sorely neglected though potentially vital audience – the staff.

Quarterly newsletters and the odd round-robin email no longer suffice. This is a sophisticated, brand-aware audience whom organisations are finding it more and more difficult to retain. Communication to help keep the troops on message is at the top of many clients' minds.

And with the blurring of products and services, even a humble shampoo could have its own retail outlet with staff, who in turn are in contact with consumers. Even without a high-street presence, customer enquiry and complaints lines are manned by people who, whether they like it or not, become the human face (or at least voice) of that brand. As Glynn Britton at Interbrand puts it: "There's no company in the world that only has an online presence – everyone has staff."

So staff are now being treated as brand ambassadors – individuals who, if they perform appropriately, can give the right impression for the brand, whether it's a product or a service. This is a long way from the idea that staff should be polite and helpful at all times. That's a given (though not always achievable).

In the same way that a bank's interiors, along with its ads, website, cheque book and cash-point design can speak volumes, so too can the staff in the branch or the call centre. Keeping all messages to the outside world consistent helps to present a strong brand. It's also a way of enhancing any differentiation that one bank might think it has over another. And a consistent message benefits staff too, who may well also be consumers.

Internal communications has long been the poor relation to advertising and even old-fashioned design, but that's changing. It's getting higher up the marketing agenda, and creativity that was once only directed at external audiences is now being directed internally, in the enlightened places at least, like Orange and Nike.

And while in the past internal comms was handled solely by specialists such as MCA Group, the branding consultancies are now attempting to get in on the act.

Tone of voice
John Simmonds at Interbrand in London describes a brand's tone of voice as an aspect of verbal identity. This is to do with all the material that a company sends out to all its audiences, and that is circulated internally. So it can have a strong impact on output from departments other than marketing.

The idea that staff are expected to speak, and in particular write in a certain way, can sound rather sinister. But if it leads to increased job satisfaction and not just increased brand expression, so much the better.

Simmonds' work at retailer Marks & Spencer included guidance for use of language on the back of food packaging. He also worked with the complaints department about the way in which complaints were handled and in what language. In the past, a complaint was dealt with initially by an unpersonalised, standard letter. Although the response could be quick, it led to time wasting, as correspondence often went on for two or three letters before anything was resolved. Now, letter writers are trusted to respond anecdotally – referring specifically to the issue in question – or to pick up the phone. "This led to improved job satisfaction," says Simmonds.

Simmonds is also writer in residence at Elida Fabergé's offices in London, with the task of improving the company's writing skills. He has been running workshops on concept writing for 35 brand managers in the deodorant category, who work across six multinational brands.

CONSULTANCIES THEMSELVES ARE BECOMING MORE AND MORE INVENTIVE ABOUT THE WAY THEY TALK TO THIS 'NEW' AUDIENCE.

This means that clients are now encouraged to think of internal comms as internal branding, so it falls nicely under the mantra of the branding consultancies. As Andy Milligan at Interbrand puts it, "People now realise that the brand can be a principle organiser for business. Before that, the brand was a way of packaging."

"As the world moves more and more towards service brands, where brands are delivered by people, it's the people that count," says Peter Matthews at Nucleus. "First Direct branded the process of phone banking. Designers have largely been involved in the manifestations of where it's seen and touched, but now it's about behaviour."

"This is the most dramatic change that I have seen," says Alan Siegel of SiegelGale. "The major change is that companies are looking to the models of successful companies like Starbucks that have integrated the brand. They are now training people to saturate the brand promise and culture so that they are united in how they present the company."

Consultancies themselves are becoming more and more inventive about the way they talk to this 'new' audience. The UK's Imagination have had it sussed for years, and their live events for Ford are legion.

The new look BP has also taken internal branding to heart. In 2001, the London offices of Enterprise IG with Landor Associates turned their hands to devising a rewards scheme for BP. Nothing new there, only this one rewarded how closely staff lived the brand. It sounds rather ominous, but perhaps that's an inevitable consequence when an area of business gets translated into brand-speak.

Workplace interiors are also affected by internal branding, for example BDG McColl's offices for Kimberly-Clark. The consultancy was appointed in December 2000 to design new offices for the company's European service centre. The new space would house together, for the first time, the internal operations of customer service, procurement and finance – that is 240 staff over four floors. The ground floor is all meeting spaces, both formal and informal, while the upper three floors are 100 percent open-plan office space.

"Innovative and thoughtful design in the new environment actively encourages and develops a new culture, which promotes team work, open communication and creativity," according to BDG McColl.

For the branding consultancies, clients' shift of attention onto internal audiences allows them to get much more involved in areas which were previously deemed out of bounds.

Rewarding on-brand behaviour Landor, who designed BP's new identity, came up with a behavioural reward scheme, based around the company's new spirit of radical openness.

The 'discuss, discover and define' programme aims to show how employees can turn BP's values into actionable behaviour that can add value and increase the company's performance. On-brand behaviour is rewarded through BP's Helios Awards, whose visual expression was devised by Landor's sister consultancy Enterprise IG.

Meanwhile, at Norway-based pharmaceuticals company Alpharma, staff were presented with a box, entitled 'Get involved' which, when opened, the concertina-folded literature springs out. Landor, who handled the project, also put workshops in place to help employees lose their old ways of doing things. The reward for an employee who behaves most accessibly all day is getting to be inaccessible for a day.

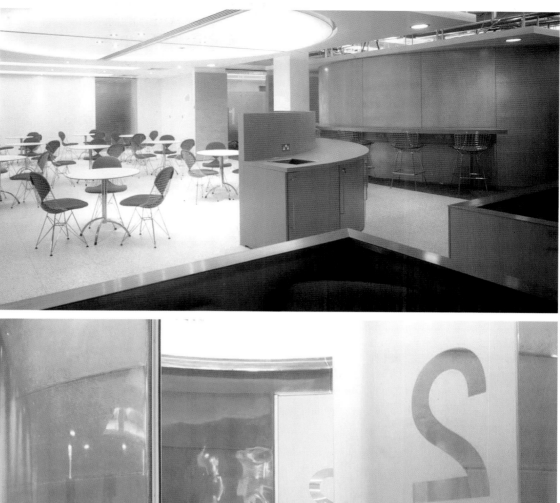

Above
BDG McColl's
new offices for
Kimberly-Clark,
photographed by
Keith Parry, exude
the firm's values.

"INTERNAL BRAND VALUES AND EXTERNAL BRAND VALUES WILL HAVE TO MATCH, OR THE CUSTOMERS WILL WALK."
KEVIN THOMPSON,
MCA GROUP

"Internal branding and living the brand are the hot topics, because what was design has turned into branding, so it's using the personality to talk to staff," says Landor's Peter Knapp. "It is a demonstration of clients' maturity of the understanding of branding." As part of their identity projects for BMI British Midland and Le Meridien hotel chain, Landor's remit went way beyond logo design.

The realisation is now sinking in that a member of staff who is not behaving on message can actually have a detrimental effect on the brand.

The external consumer thinks about your brand for eight minutes a year, the internal one for eight hours a day, according to Kevin Thompson at MCA Group. For a brand whose staff are not acting in its best interest, the implications are serious.

Customers defect when they have a bad experience with a brand, and that could well be when they were in contact with an employee. "And once people defect, they become terrorists," says Thompson. "Internal brand values and external brand values will have to match, or the customers will walk."

Fitch sees choice and training of staff as make or break for some clients. "We are developing a retail experience for a client at the moment, and a critical factor is who will staff it," says John Mathers. "It's a high tech product and the concept will fail if they have conventional sales people. We are helping to define how staff should behave and the atmosphere and props. In the next two to three years it will go live."

Fitch:London is also working with De Post, Belgium's post office. "The success or failure of the branding work will come from the retail environment and the retraining of staff to think in a different way, from public service to retailers," says Mathers.

The budgets for internal comms are still a fraction of clients' external marketing budgets. Kevin Thompson looks forward to the day when internal comms accounts for ten percent of the total marketing spend. In the meantime, manifestations of internal comms are likely to suffer from a lack of imagination. Some staff are luckier these days. Employees at the German telecomms venture Ish – which was branded by Venture 3 (Lucky's previous incarnation) – are more familiar with mock demonstrations, slap-up meals and show-and-tell sessions than they are with intranet sites.

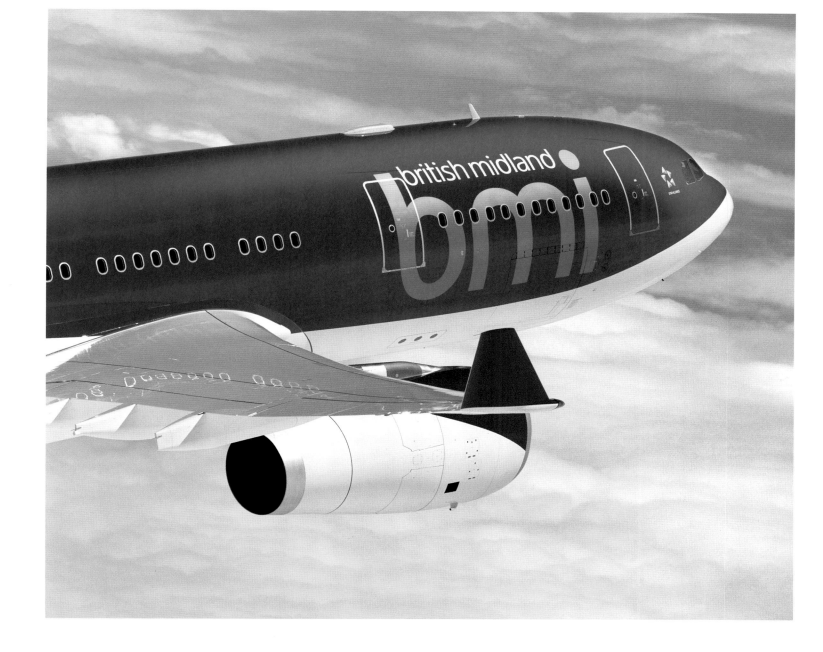

Designing speech (l)
As a consequence of Landor's work, BMI British Midland (right) passengers are now greeted with "Hello again", by cabin crew when they go on board. This is a way of expressing the informality and friendliness of the airline – though when used to greet first time passengers, it would be factually incorrect.

Sometimes staff morale can lift when internal branding is simply tidied up. At Manchester United, the internal audience can now unite around one brand, following Springetts' design audit. In the old days, if Manchester United's operational divisions were represented in one meeting, a clutch of different business cards would appear on the table – confusing for the insiders as well as the outside world.

It's not only existing staff who are being taken into account when it comes to branding. Potential recruits are another valued audience. If they're taken on, they need to be imbued with the corporate values from the start. If they don't make the grade, an unfavourable impression of the company could turn them – as it can a disgruntled customer – into that most feared beast, the dreaded brand terrorist.

So their experience of any potential new employer, from recruitment literature to the interview environment, all play a part in creating the right impression. Workspace designers Tilney Shane found this out in their project for British Airways Human Resource's recruitment facility.

At the US Air Force, recruitment and retention was an issue. As part of SiegelGale's repositioning of the organisation, they created four commercials, aimed at four different audiences, including one for existing personnel, one for recruits, and another for influencers such as parents and high-school guidance counsellors. Each ad had a message that was specially tailored for that audience.

Some consultancies, however, are accused of being over-enthusiastic about their skills when it comes to internal branding. This is a tricky area, not least because it is likely to come under the remit of human resources (HR) rather than the marketing department. David Mercer, design manager at BT, is blunt about design consultancies' limitations in this area: "Design companies can't do things like changing staff behaviour, that is cultural change. And anyway, culture is not my job, it's HR and operations. All the agencies I've worked with on brand identity are not capable of doing behavioural change."

While the execution of the brand is the responsibility of different client departments – marketing and HR in this case – there is the potential for disparity.

Designing speech (II)
When Landor rebranded Le Meridien hotel chain (opposite), staff were advised to greet guests with "Bonjour", regardless of the location. Landor's Peter Knapp calls it an attempt to re-establish the specific 'Europeness' Le Meridien had.

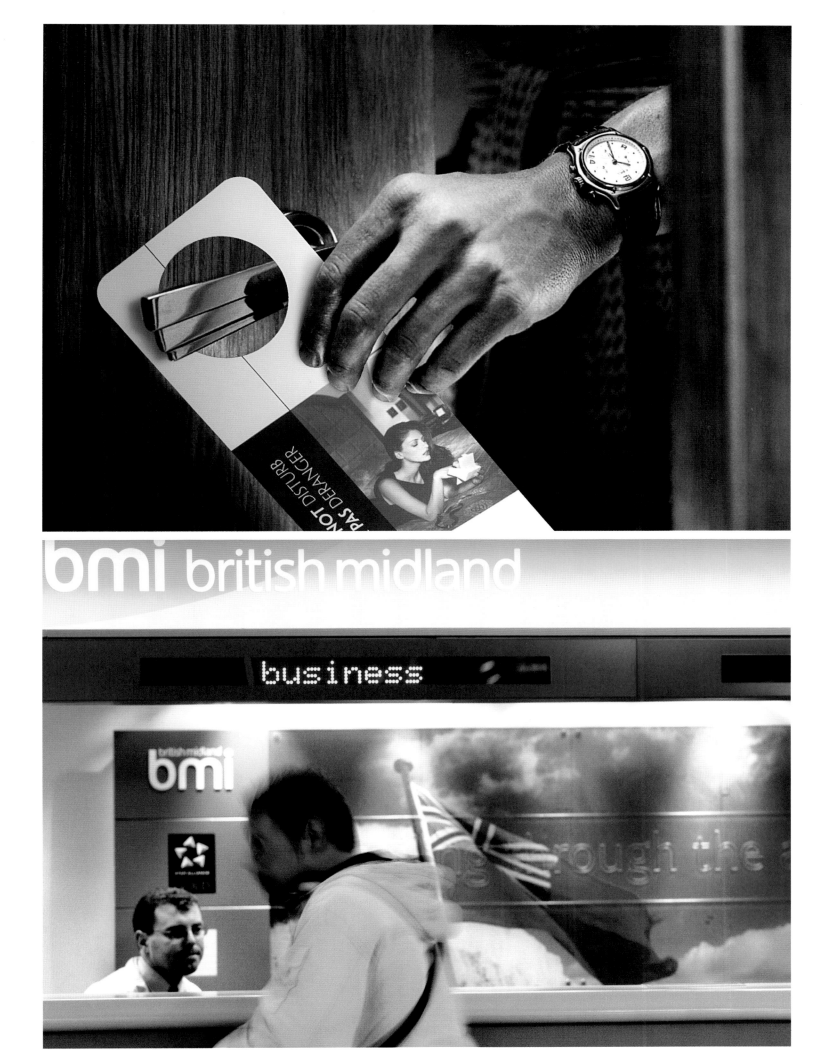

When Venture 3 was appointed to create a brand for a new German telecomms venture, its thinking went way beyond intranet sites and corporate packs to get the staff involved.

"Companies can't deliver the brand if they don't live the brand. We help shape a brand that they can believe in," says Venture 3's Michael Zur-Szpiro.

Staff became involved in graffiti, model building and mock political demonstrations. Not your usual internal brand building stuff, and infinitely more rewarding.

The venture was conceived when a number of old, established cable and telecomms businesses were sold off by Deutsche Telekom. "Our objective was to turn these networks, which were very conservatively run, into a single network that could deliver the new service of TV, broadband and internet and transform the mindset of the company," says vice president head of strategy and marketing, Bradley Herman.

"It was about changing federal employees of Deutsche Telekom into the most progressive thinkers on entertainment and the media," Zur-Szpiro adds.

Herman says that Venture 3 was not just asked to come up with a brand for the consumer market, but with something that would encapsulate the internal culture the management wanted to create, and to help them communicate or 'inoculate' everyone with that new culture.

The identity of the venture was developed in tandem with the staff activities, meaning the solution really was informed by their input. The eventual identity was a world away from most telecomms businesses (and most German businesses of any type), and a huge step for an organisation that drew its employees from the state-run animal that was Deutsche Telekom.

The name, ish, was represented by a Manga-style identity, which literally swayed like hair or seaweed when it was animated. "We wanted the brand to feel magical," says Paul Townsin at Venture 3.

This idea was received favourably by staff, because they had been so involved in the process. This started with a questionnaire, through which Venture 3 selected individuals to take part in the brand development and feed back the goings on to colleagues.

CASE STUDY
ISH

TURNING PUBLIC
SERVICE STAFF INTO
BRAND WARRIORS

Above
Employees at
German venture ish
swopped Smart cars
in favour of the new
Mini as their principle
fleet vehicle.

"We created a weird application form about becoming an ambassador for the brand, with questions like: if you had been in the Garden of Eden, would you have eaten the apple?" says Zur-Szpiro. The idea was to get staff out of conventional form-filling mode. Venture 3 picked out 30 entrants with the most original answers. Then the fun started.

The chosen ones were asked to graffiti a wall, elements of which were then photographed and turned into stickers. These were stuck wherever they liked, as a way of spreading a message. They were then turned into a set of postcards.

The ambassadors were also asked to bring in objects that represented for them the qualities of wild, natural and alive – the three brand values that Venture 3 had defined. One man brought in his young daughter.

Other activities included building a model of the ish high-street store and training centre, and staging a demonstration, imagining that ish had been taken over by the regime.

Photography from many of these exercises was turned into a magazine. Each ambassador was given 20 copies and 100 Deutschmarks to take their team out for supper and show them what they'd been up to. Zur-Szpiro describes it as a unique communications channel, and much less patronising than an intranet site.

"We did all this in the summer when there was no logo and no name, so people understood that the brand is not about the logo and name. It's about people telling stories. It becomes a gossip exercise," says Zur-Szpiro.

He adds that these former federal employees became so taken with this process that "they went from being passive volunteers to waiting impatiently for the next thing", he adds.

Below/Opposite
Venture 3's
application of
the ish brand
to products
for internal use.

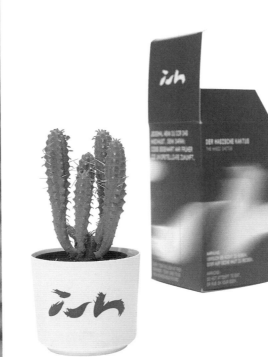

Much of the fruits of these exercises have actually fed back into the outward-facing communications. The shots that went into the staff magazine were then to be used for literature for external audiences; some of the design ideas for the store and training centre were fed on to the architects; and the Mini is ish's fleet vehicle because the staff preferred it over the Smart car, which was the original suggestion.

For Herman, the manner in which the staff got involved was a world away from what one would expect from the traditional German worker. "Even the service technicians and people in call centres were brilliantly imaginative, creative and enthusiastic about it," he says, citing the ideas and poetry that went into the magazine.

The identity was finally unveiled at a sort of 'ambassadors' reception', a party for the staff hosted by the 30 volunteers. "If you can include people in the process of the identity they take ownership of the spirit of the brand," says Zur-Szpiro. This happened three months before the name and identity went live to the outside world.

However, converting an entire workforce can't be done in one go. Herman admits that "when the brand ambassadors came to communicate their feelings about the new business to the rest of the employees, there was a certain amount of cynicism." That's hardly surprising, he says, as civil servants are unlikely to want things to change. In research carried out immediately after the brand was revealed in July 2001, 50 percent of staff loved it, with the rest being either indifferent or loathing it. By March 2002, 95 percent of ish's 2,300 staff are reported as loving it.

Venture 3 is now working on an induction programme, so that new employees are 'inoculated' when they join.

Home sweet home, try out some of our products, see for yourself the benefits of broadband 3 in 1, ish telefon, ish internet and ish TV.

Above/Opposite
Instead of doing
a corporate brochure,
Venture 3 came up
with a CD-Rom game
which presented the
same material in a
much more playful
and ish-like manner.

Home sweet home, try out some of our products, see for yourself the benefits of broadband 3 in 1, ish telefon, ish internet and ish TV.

Cruise through the ish valley, travel along the Rhein discovering facts about Nordrhein-Westphalen and Baden-Württemberg, some useful some just wild! Discover why ish began life here.

Cruise through the ish valley, as you travel along the Rhein you'll discover facts about Nordrhein-Westphalen and Baden-Württemberg, some useful, some just wild! Discover why ish began life here.

ISSUES OF STAFF RETENTION TACKLED THROUGH IMAGE

Much of SiegelGale's repositioning for the US Air Force (USAF) had an internal focus. Kenneth R Cooke at the New York-based consultancy describes it as being "plagued by tribalism, declining enlistment and low staff retention".

Alan Siegel adds: "The force felt they were misunderstood, and they weren't recruiting well. They needed to stimulate the people. They were having problems in enlistment, and retaining their top staff."

In an effort to speak to a new generation of recruits and active duty personnel in a more contemporary voice, the USAF embarked on a rebranding programme in 1999. The consultancy's brief was to unify the culture and reinforce the USAF's mission.

As part of their research, SiegelGale visited airbases and command centres around the world, examined historical artefacts, audited communications, and conducted interviews with airmen; from generals to government officials. And all this with an organisation that is unsurprisingly much less open than your average civilian client.

The research threw up the fact that the USAF already had some appropriate values: excellence in everything they do, service before self, and integrity. However, these differed considerably from the perceptions of the outside world. Outsiders saw them as nine-to-fivers rather than warriors. "They were seen as professional, but soft," says Cooke.

The force's existing slogan for recruitment projects was 'Aim High'. But the feeling was that this did little to express the force's three values. And when put up against the competition – the Marines, who use the line 'The Few, the Proud' – the USAF's message seemed even less compelling.

The line 'No One Comes Close' was the fruit of a chance conversation with commander in an allied force. This, SiegelGale believed, could act as a rallying cry for active duty personnel and recruiting efforts, as well as working as an effective descriptor for the general public.

The consultancy then went through the sensitive process of modernising the logo, the symbol created by General Hap Arnold. This new marque was launched through a series of TV commercials, also created by SiegelGale.

Four commercials were aired, each with a different message for a different audience. Cooke explains: "For existing personnel, the message was: we understand the sacrifices you and your family make everyday to protect America. For recruits, the message was: join the best air force in the world and learn the best technology. For influencers like parents and high-school guidance counsellors, the message was: this is an air force of integrity, excellence and service before self. The fourth commercial was general purpose, and showed in cinemas countrywide.

The commercials ran continuously for almost 18 months, and were then re-purposed in response to the terrorist attacks of September 11. "Research by the Air Force has shown double digit improvement in perceptions of the USAF," says Cooke, with the recruiting goal for 2001 being met by May of that year.

Opposite
Various applications of the newly modernised US Air Force logo designed by SiegelGale.

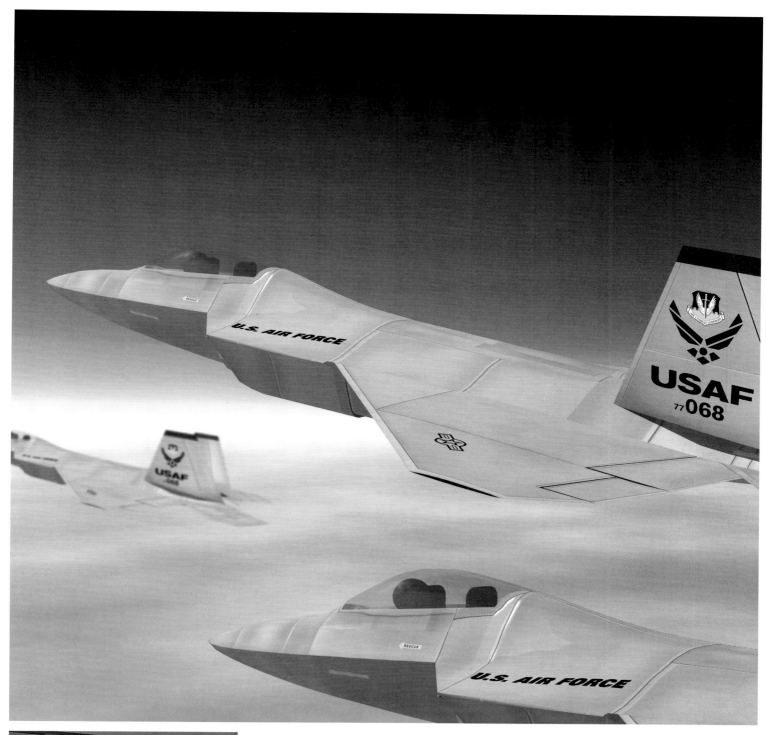

Below/Opposite
SiegalGale came up
with TV commercials
which featured the
strapline 'No one
comes close'.

Below/Opposite
The four TV
commercials were
aimed at different
audiences, but all had
an emphasis on the
experience of staff and
potential recruits.

Paid for by the U.S. Air Force.

AMERICA'S AIR FORCE

airforce.c

KEEPING WORKERS ON BOARD THROUGH CHANGE

The importance of keeping staff on-board during a major identity change can never be underestimated. The Hong Kong Post Office learnt this when it went through its revamp in 1997.

Staff morale or retention was not the main reason for making the changes. The Post Office, which was established there in 1841, had a very low labour turnover. Most staff tended to see it as a job for life, with postmen being well respected in the colony, as it was at the time.

One of the Post Office's missions was to have "a highly motivated, satisfied and valued workforce". But the main reason for the change was to get away from its image as being bureaucratic and to focus on customer friendliness.

Enterprise IG's Hong Kong office was appointed to come up with a new name and identity and to manage the process of change. The naming was fairly straightforward – Hong Kong Post is punchier and did away with the archaic 'office'. The rather British red and blue colours were dropped in favour of purple and green; and the old-fashioned stamp-like symbol was replaced with that of a hummingbird.

Given the amount of contact that its staff had with customers – in more than 100 branches and at every front door – internal communications of the changes should have been at the forefront of the management's mind.

And while the rebranding was deemed a success, the management admits that in retrospect more effort could have been made to get the staff on board at an earlier stage.

For example, staff training in the new ways of the Post Office was not started until the new identity was unveiled. This meant that although customers could see a difference, they didn't immediately experience one.

However, much was done during the identity process to include employees. Opinions were sought from staff unions, and perhaps most importantly, staff were consulted on their new uniforms.

More than 2,000 staff wore uniforms, and it was this part of the identity programme which particularly attracted their attention.

Enterprise IG's uniform designer created a new look which was intended to be professional yet practical. Staff were consulted throughout the process; trying on samples and having their recommendations taken on board. For example, the polo T-shirt was swapped for a shirt, as these were stiffer, held their shape better and had a top pocket for the message cards that the postmen carry.

Since the introduction of the new uniforms, Debora Chatwin, of Enterprise IG in Hong Kong, says that she has spotted a new, younger breed of postal employee pounding the pavement. "Believe me, you can't miss them now with their distinctive uniforms, which they clearly wear with a great deal of pride. They've got these fabulous Gortex jackets and polar vests, as it does get chilly here in the winter," she says. "Sure beats the uniforms they used to have which consisted of an itchy blue gabardine trouser made by the Correctional Services Institute! They looked like inmates!"

For the Hong Kong Post's management, the core objective was to create a customer-oriented image. However, a beneficial side effect was the improvement in morale and enhanced internal communications.

HONG KONG POST OFFICE

Hongkong Post 香港郵政

Above
The old logo above
and Enterprise
IG's new look and
shortened name.

Right
The new Hong
Kong Post identity
out on the road.
Photography by
Alan Soo.

Below
Postal workers influenced the choice of clothing for their new uniform.

Opposite
The branch staff also received smart new work wear. All photography by Alan Soo.

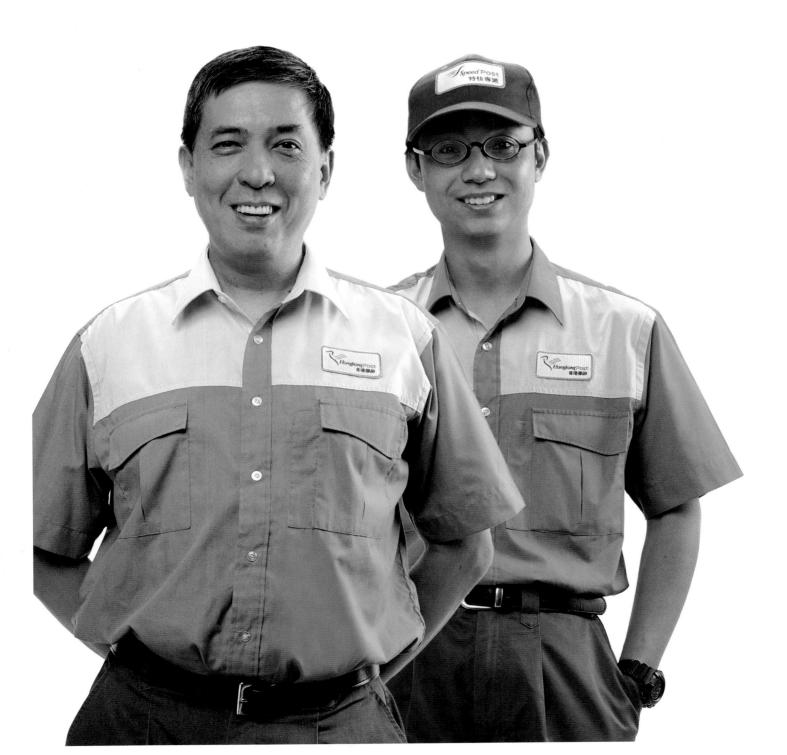

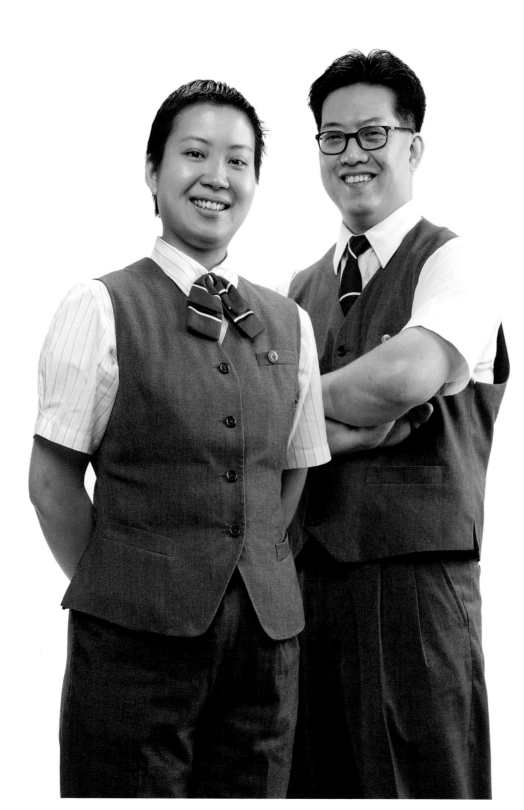

CHAPTER 4
NEW COMPANY STRUCTURE

THE FOURTH ROOM
SAFFRON
VENTURE 3
WINK MEDIA
STOCKHOLM DESIGN LAB
CDT
CURIOSITY
HOSKER MOORE KENT MELIA

NEW COMPANY STRUCTURE

AS THE DESIGN BUSINESS CONTINUES TO EVOLVE BEYOND LOGOS, THERE IS AN IMPACT ON THE DESIGN INDUSTRY ITSELF.

INDIVIDUALS AND STUDIOS MUST WORK OUT WHERE THEY FIT IN TO ALL THIS, AND THEIR DECISION WILL AFFECT HOW THEY ARE PERCEIVED AND HANDLED BY CLIENTS.

There currently seem to be three schools of thought on the best way to service clients: you can offer everything, or as much as possible under one roof; you can offer everything through a network of individual sister companies; or you can specialise in one or two areas.

The big marketing services networks, such as WPP, Omnicom, Cordiant and The Interpublic Group favour the first or second route through their branding divisions: Enterprise IG, Interbrand, Fitch and FutureBrand respectively.

However, in the UK at least, there are a growing number of design people and, more importantly, clients who are leaning towards the specialist approach.

The first two routes have a business logic to them. "At the top end, people are becoming more multi-disciplinary, offering a more holistic approach. You can charge more if you offer more," says Lynda Relph-Knight, editor of Design Week magazine in London.

And the more places in which you have a presence, the more work you can pick up. This is particularly the case for big, global projects, where international stretch is seen as most useful by the clients. To be able to say at a pitch for an intercontinental rebranding project that you have numerous sister offices in those exact same continents counts for a lot.

In the case of design, for the last ten years or so this normally involves buying up businesses around the globe, instilling the methodology of the original or dominant office, and changing all the names so that there is the suggestion of a cohesive brand.

Hence the Sydney design business, Horniak & Canny, once it became part of Enterprise IG, changed its name to Enterprise Horniak & Canny; or the Swiss identity consultants Zintzmeyer & Lux, which since its purchase by Interbrand, uses that name as a prefix; or the dozen or so agencies around the world such as PrimoAngeli:Fitch, which now have the word Fitch attached to their name.

These relationships often start life as affiliations, while the potential purchaser looks to see whether there could be a natural fit, and checks out how good the business's client contacts really are.

Not all overseas offices are acquisitions though. Some are started from scratch, normally by a couple of pioneering senior people from home base. This was the case in Australia for FutureBrand, where Matthew de Villier was sent out to put together a team and create a Sydney office.

Either way, the growth of these design, identity and brand networks has been a way for these big, premier league players to compete effectively for some of the massive identity projects that have been up for grabs in recent years. And clients got into the habit of turning to these agencies.

THE GROWTH OF THESE NETWORKS HAS BEEN A WAY FOR PREMIER LEAGUE PLAYERS TO COMPETE EFFECTIVELY FOR SOME OF THE MASSIVE IDENTITY PROJECTS.

"The future is the hybrid, like Fitch:London, Landor and FutureBrand," says Fitch's John Mathers. "Clients are seeing the benefit of having a strategic partner for the brand thinking who can also do the brand expression."

It is his belief that clients are demanding a much broader range of skills and expertise than before. Product design, live events, experience, showrooms, and merchandise as well as graphics. "Clients don't want to go to different people for different bits," he adds.

This attitude has left the smaller consultancies out in the cold for the most part, but two things have happened that seem to be changing that.

For a start, there were fewer massive naming and identity jobs around in 2002, and at the same time, the savvier clients were having a go at doing things differently for a change. The falling number of such projects was a reflection on the struggling world economy. Greatly reduced marketing budgets meant there were few big repositionings going on. Deregulation, which led to a host of newly named private businesses, had pretty much all happened in the 1980s and 1990s. The bottom had dropped out of the dotcom sector. And that staple of the big agencies which also offer naming – the merger and acquisition market – had mostly dried up.

This is not to suggest that nobody was doing anything. Businesses were still launching or repositioning, and clients were still needing to keep their brand fresh. Hence the rise of the brand guardianship role, as discussed in Chapter 3.

But rather than turning to a big agency, there was evidence that clients, particularly in the UK, were increasingly doing it for themselves.

This means they were pulling together bespoke teams of specialists to work on specific projects. These could be individuals from different consultancies, or teams of smaller businesses.

As David Mercer at BT says: "My view is that we buy individuals to do specific jobs. One-stop-shops don't work (for us) because it's down to individuals." In his opinion, the big agencies "try to sell you everything, but we wouldn't buy it".

The UK telecomms business Orange works like this some of the time, as does Camelot, the operator of the National Lottery. While the responsibility of the brand lies with the 28-strong internal marketing team, the ad agency WCRS acts as Camelot's lead communications consultancy, under which a number of smaller, niche businesses operate. Hence the new Camelot identity was designed by Smith & Milton, a design agency. "Nobody should know the brand better than the people who own it," says Dianne Thompson, CEO of Camelot.

"NOBODY SHOULD KNOW THE BRAND BETTER THAN THE PEOPLE WHO OWN IT."
DIANNE THOMPSON, CEO, CAMELOT

The sorts of studios to benefit from this include GBH, CDT, SEA and North. These are the sorts of relatively small graphics agencies which are brought in to come up with a creative solution. They are likely to be used when the client really knows their mind, has worked out the brand strategy, and needs some graphic magic.

Hence North's identity for the UK motoring service RAC, following the strategic thinking that was put in place with the help of external brand and marketing consultant, Jarvis (see Chapter 5).

And hence GBH's identity for Spanish telecomms company Teleconnect, which offers residential and business services. Teleconnect's positioning is 'the messenger' and its solution has a human feel, with the icon having a number of varied applications.

But outside graphics, other sorts of companies are finding niches for themselves. The now defunct Fourth Room did up-stream thinking – the term for creating concepts and initiating strategies. This was then turned into branding or marketing strategy. Although some of its founders came out of the identity consultancy Newell and Sorrell, The Fourth Room bought in other people to execute the design, preferring to concentrate on the thinking.

Meanwhile, Circus was set up as solutions neutral (i.e. an unbiased approach), with its founders and staff coming from advertising, design, brand experience and from the client side.

Then there's Engine, a duo who left product design company Priestman Goode to help companies breathe new life into their brand strategies. Again, these people are thinkers, and bring in other specialists for the doing.

CDT made a conscious decision in 1996 to 1997 not to try and become a branding consultancy, and to stick to its guns as a crafts-based graphics agency with strong creative ideas. The decision seems to have paid off, as the steady stream of well-crafted identities shows.

So this perceived sea change is a result of the clients asking for different things (perhaps less radical jobs) and asking for those things differently (collecting together a group of specialists rather than always going to a one-stop-shop). Smaller, independent agencies are in a good position to take advantage of these developments, but only if they are honest about what they can do.

In the last few years, many perfectly good design groups have jumped on the strategy bandwagon, hoping for greater rewards. But unless they can back this up with genuine expertise, clients are let down. As Mercer says: "A lot of companies are riding on the back of brand strategy but they can't deliver it, they can deliver creativity

Left
SEA designed the identity and launch book for a new office furniture systems business.

The Fourth Room was a firm of creative strategists drawn from conventional brand consultancies, client companies, the research sector and other diverse industries from the law to journalism.

It was founded in 1998 by Michael Wolff, co-founder of Wolff Olins, Piers Schmidt, formerly head of strategy at Newell and Sorrell, and Wendy Gordon, co-founder of Research Business International. (Sadly, a bust-up among some founders,coupled with the poor climate led the company to go under in thesummer of 2002 - one of a number of casualties in this sector. Still, there are lessons to be learned from the way the consultancy managed to carve a niche from itself.)

"I first started realising that we ought to be doing more for the clients in 1993 to 1994," says Schmidt, who is credited with the multi-cultural rebranding of British Airways. "There was a lack of depth, and what we gave clients was not doing much for them."

They saw an opportunity to fill the gap in the market between the creative solutions of design and ad agencies, and the rational recommendations of the management consultancies.

Clients were suffering and in need of a particular kind of help. Schmidt explains: "CEOs have done growth through cost reduction, but they have shed all the fat, and have started hacking off limbs – an example is BA outsourcing its catering. CEOs are accountant types not wired for customer and branding stuff. So growth is a headache for them.

"We talked to clients about brands because brands are absolutely fundamental in describing the quality of the relationship between the company and the consumer. If you believe that growth is going to come from the market and the customer, then brand is a key feature of the market – that's why we still talked to companies about brand."

A conventional brand agency would also talk about growth through brand, but Schmidt maintains that these agencies are not structured to deliver on all elements of their promise.

There are four skill sets or abilities required to be able to implement successful brand management, according to Schmidt. These are: an understanding of how to develop a product or service; the people and how they behave; environments; and communications. The brand is a product of the consumer experience of these four things.

"But communications aren't working so well because the consumer is more sophisticated. So how products and services and staff are becomes more important. So you dramatise your brand through places. So designers say they will help the client design the product, and will train the workforce, and change the identity, communications and environments. But it's impossible to do all that. Our role was to make clients understand how this worked," he says.

In the early days, The Fourth Room team found it difficult to articulate this effectively to potential clients. "When we explained it to clients we got the nodding dog syndrome," (i.e. they were agreeing but couldn't see what The Fourth Room were actually selling). They were fortunate to have a year to sort this out, as product design company Ideo stepped in and "bank-rolled us through that discovery. We had the luxury of the time to figure out (for ourselves) what we were selling," says Schmidt.

Four years later, they stopped talking about what it was, and talked about what it did. "What we did helped clients grow revenues. We were a team of creative strategists. We used that description because it did what it said on the tin, and there were not many of us around. We counselled senior people in business."

One of The Fourth Room's premises was that clients don't actually own their brands. "We said that the consumer owns the brand through their experience. And you don't control many of the touch-points." This is invariably an uncomfortable realisation, as a client would need to then restructure to appreciate and act on this.

Opposite
The Fourth Room creative strategy influenced furniture retailer MFI's store redesign.

As clients became increasingly comfortable with The Fourth Room's offer, more interesting work came in. Sun International Hotels, which owns and manages resort hotels and casinos, was one such client. The consultancy helped them rebrand, with a new corporate name and brand architecture, following Sun International's split from its South African sister company. The repositioning of the MFI furniture retail chain, making it more contemporary and relevant, was another "challenge".

Many of the assignments have been in innovation and the searching out of new consumer groups. The Fourth Room developed concepts for six new types of sugar-based product for chocolate manufacturer Mars. They worked with British Bakeries, helping identify internal blockages to innovation in the Hovis marketing team, and speeding up getting new products to market. For Sara Lee, they came up with new ways to innovate in the washing and bathing market. This involved getting ordinary people to video their own washing and bathing behaviour in order to really understand how they lived, where the brands fitted into their lives and how they used them. This was a useful exercise for the brand owner, too.

In The Fourth Room's experience, brand owners often assume that their brand is the centre of the customer's world, and their communication with customers is based on this assumption. Filming people in their baths is a very powerful way of bringing the reality to life.

And while The Fourth Room did the up-stream creative strategy, the design work was carried out by agencies, whom they have sometimes recommended. So Pentagram is working on Sun International, CDT carried out the design work for fibre optics network 186k following The Fourth Room's naming strategy, Conran Design Group carried out the interiors and graphics for MFI, and the new RIBA identity was by Atelier Works. As well as design, the consultancy was also up-stream of ad agencies, PR companies, and any communications company that carried out execution. Which made The Fourth Room one of the few businesses that genuinely used that covetable descriptor: solutions neutral.

Opposite/Overleaf
The Fourth Room worked with CDT which designed the identity of fibre optics network 186k. The creative director was Iain Crockart and Stuart Young was the designer.

186*k*

186*k*

186*k*

186*k*

TRYING TO BREAK THE MOULD AGAIN

Saffron was set up in 2001 by Jacob Benbunan, who hopes that it will have a different focus from conventional brand consultancies.

Saffron is based in Madrid, where Benbunan used to run Wolff Olins' Spanish office. He left Wolff Olins in 2000, and was chief executive of the broad band and internet arm of Spanish telecomms business, Ono, before setting up Saffron.

"Saffron is the result of my frustration with Wolff Olins," he says. "I'm learning from their mistakes, and trying to break the mould again."

With Landor and FutureBrand in Madrid, as well as an array of local firms, Saffron has some well-established competition.

"All the major consultancies have brand formulas that they use with clients, but we feel that every brand is unique and you have to approach each job in a different way."

The consultancy, he says, will have a more boutique style than a mainstream one. The focus will be on service industries rather than FMCGs, and on internal rather than external audiences. "The values that we create for an organisation transpire within rather than without," says Benbunan, who has recruited the HR manager from Ono.

The Spanish market is not really mature enough for this offer, Benbunan admits, but then he doesn't want to restrict business to the local market, anyway. Saffron already has clients in the UK, France, Brazil and Mexico, as well as Spain. Culturally at least, the consultancy is well positioned for such international work. Its 16 staff cover eight nationalities and speak seven different languages.

While business builds up in the internal comms area, Saffron is happy doing more conventional identity work. Hence the project for the National Housing Federation in London. While Wally Olins advised on the task of changing the public perception of social housing, Saffron worked on the visual manifestation of the Federation's image.

However, Benbunan is "sceptical about graphics and logos" in isolation. "Any name and symbol can work," he says. "What's more important is the personality." He cites the Spanish department-store chain, El Corte Ingles, as an example, where he says the value is in what it stands for rather than in the meaning of the name (The English Cut) or the symbol.

Opposite
Mino is the brand name for a video, web and interactive TV set-top box. Saffron created a mascot that went through a daily evolution, just as viewers' lives evolved daily.

THE OPPORTUNITY TO CREATE A NEW-STYLE BRAND CONSULTANCY

"We felt that the big identity firms had become a bit tired, we wanted to shape our own destiny and we saw an opportunity to create 'what will be'" – i.e. a new style consultancy for the future. So says Philip Orwell, one of the founders of Venture 3.

Apart from those that are started by recent graduates, most companies begin life as some sort of spin-off or break-away. In that respect, Venture 3 is no different – its three founders had all worked at Wolff Olins.

But Venture 3 had big ambitions from the first day, and the credentials to pull them off. It's no mean feat to jump straight into the major league identity arena, but this is what it has managed to do. Philip Orwell, Michael Zur-Szpiro and Paul Townsin had all worked at Wolff Olins and were middle or senior level when they left. This helped them leapfrog some other start-ups. "Clients want creative work but they also want help to sell that into their own board. There is a political side," says Orwell. "We deliberately set up with the infrastructure (in place) to handle major projects."

They established the company as Venture 3 in 2000 and in its first year achieved a fee income of nearly 2.3 million pounds. The company employed 16 people by early 2002.

"Our model is to work with a very small number of large clients at any one time," says Orwell. "The relationship should be deep, intensive and long. We want to be the leader of the orchestra, rather than brand guardian."

The founders of Venture 3 are very clear about the sort of big clients they want to work with. They seek out high-placed individuals who have the confidence to do something different. In Orwell's opinion, there are more of these people out there.

Early work included design of an online portal for Credit Suisse's European personal investors, branding work for Munich technology company memIQ, and Scor, a French reinsurer. It also got down to the last two for the creation of the identity of the new national airline of Switzerland, Swiss.

Its biggest client to date has been the German telecomms business, ish. This was the first business in Germany to bring the phone, internet and TV to the consumer. Ish's vice president of strategy and marketing, Bradley Herman, had worked with Venture 3's founders when they were at Wolff Olins. Together they had created the brand for the Spanish telecomms brand, Ono. He returned to Wolff Olins for the branding of ish, but "got fed up with them after a couple of months. We felt we were part of a conveyor belt system."

He then turned to the newly founded consultancy, which he describes as being "like Wolff Olins was five or six years ago. They're very hands-on, fun to work with, they make you think and make you laugh."

However, it took Herman a couple of months to make up his mind to go with such a fledgling group, and to convince his CEO. In the meantime, Venture 3 built up a German team to work on the project.

Venture 3 came up with the values and the name of ish, which narrowly beat the moniker Fonk. Their remit went way beyond the logo, from the internal launch to an interactive game. And the logo itself was turned into a three-dimensional model to give away, as well as a vast sculpture.

"We think of ourselves as a creative studio rather than a management consultancy that specialises in brands," says Orwell. Creativity may be important to them, but at the same time, Venture 3 has grown-up ambitions.

Orwell and the other founders want to build a business in Germany, and double the size of the London studio. "We are a serious business and we want to grow," he adds.

At this rate, Venture 3 could be one of the few serious contenders to the well-established major brand consultancies in the UK.

Right
Ish stationery,
designed by
Venture 3.

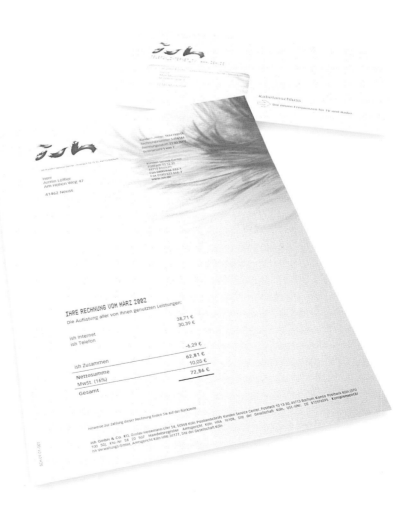

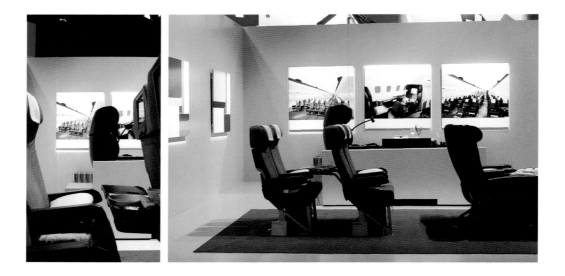

CASE STUDY
WINK MEDIA

BORN OUT OF THE
MAGAZINE WORLD

Wink Media's conception must be unique among graphics agencies. It was founded because of a client approach to the international style and design magazine, Wallpaper*. The fashion retailer, Banana Republic, contacted Wallpaper*'s founder, Tyler Brûlé, asking if the magazine could help set up some shops. That was the inspiration, and since then Wink hasn't looked back.

It now offers graphic design in the form of advertising and identity, and contract publishing. That mix of disciplines is in itself not the norm, but it was Wink's close link with a magazine that made it really unusual at the start. "Wallpaper* was a great resource for Wink," says managing director Matthew Warren, who was previously with Wolff Olins. "We are very independent but we were able to draw on the magazine's knowledge of architecture and fashion. It creates another difference for us."

That means the company has an unusually strong sense of new trends. Since summer 2002, Wink has been disassociated with Wallpaper* magazine, with Brûlé stepping down as editor, but Wink still maintains its editorial interests through contract publishing.

Many clients enjoyed the caché from being involved, even vicariously, with Wallpaper*. (They must have been hoping that a bit of the Wallpaper* magic would rub off.) And conversely, Wallpaper* had a higher profile than the average creative agency could ever dream of. It was an article that Brûlé, as the magazine's editorial director, wrote in a Swiss newspaper that got Wink (of which he is creative director) onto the pitch list for the country's new airline at the end of 2001. In it, he outlined his vision for the sort of airline that could grow out of Cross Air and the defunct Swiss Air. "Wink would never have been on the list if Tyler hadn't done the article in Der Zeitung," says Barbara Tischhauser, manager of brand and identity for the new airline, called Swiss.

Amazingly, Wink beat off competition from 19 other agencies, including Interbrand's Swiss arm Zintzmeyer & Lux (who had a long-standing relationship with the airline company), FutureBrand, Swiss agency Wirz Id which branded Swisscom, and Wolff Olins spin-off, Venture 3, in London.

The branding of Swiss was a huge undertaking for Wink, but it was exactly the type of client the agency is after. "We are about high quality creative work for quality brands," says Warren, "not just the luxury goods market but brands that do things well and are innovative." Meaning Wink would be as pleased to work for Tesco as they are for Selfridges.

Wink is still a young company, employing half a dozen young, mostly Swedish, designers. While not done intentionally, this Swedish input fosters a Scandinavian style that is clean, uncomplicated and elegant. But Warren is quick to point out that not all the work is minimalist. Although the identity for Swiss is very simple, the application is warmer. And the identity for Kuwaiti luxury department store, Villa Moda, is decidedly complex.

Given the age of the agency, and the nature of its former sister company, it's not surprising that many early client contacts came through the profile of the magazine. Wink must now stand on its own two feet. With the work for Swiss, it seems that Wink is indeed beginning to build a name for itself.

Below
Uniform ideas
for Swiss staff.

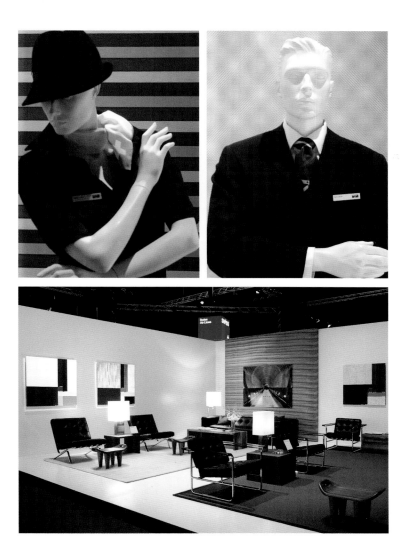

Above
Lounge concept
for the airline.

Below
Sketch of an
aircraft with
Wink's new Swiss
logo applied.

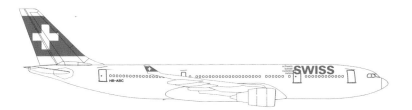

 swiss schweiz
suisse
svizzera
svizra

Left/Below
The new
international
Swiss logo.

Opposite
Wink's logos for
fashion store
Villa Moda and
fashion designer
Stella McCartney.

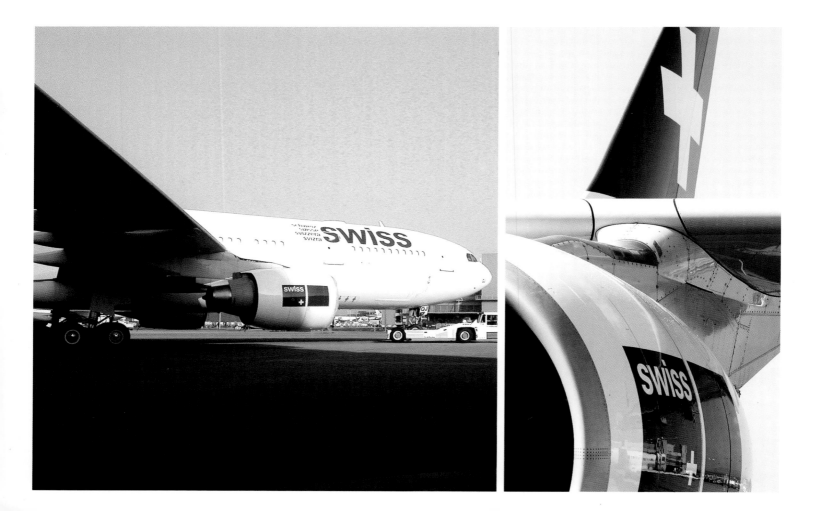

VILA MODA

STELLA McCARTNEY

CASE STUDY
STOCKHOLM DESIGN LAB

BRANDING IS MORE THAN APPLYING GRAPHICS

For Stockholm Design Lab (SDL), less is more. SDL is a dozen or so people working out of Sweden's capital on identity, packaging and on-screen products. They also work on building products through a sister company, the architectural firm Teark. The architects were responsible for Wallpaper* magazine's offices and Audi's showroom/experiential environment in London. On-screen, SDL was behind the TV idents for the 2000 Eurovision Song Contest, hosted by Sweden, which got 110 million viewers.

SDL founders believed they spotted a gap in the market in 1998, to present what they describe as a more holistic view of design, where marques are not just stamped on every product.

SDL's philosophy has been very positively received. Their holistic approach "is more efficient than an ad because it conveys the soul of the company in an interactive way", adds Göran Lagerström of SDL.

This was proved to great effect with SAS's wetwipe, whose packaging was designed by SDL as part of their rebranding of the airline.

This was an unbranded wetwipe – something of a phenomenon in the airline industry, where almost everything that the passenger comes into contact with is plastered with a logo.

The wetwipe became the most stolen item from any tray in the industry, making it at the same time the most popular. SDL puts this down to the fact that it doesn't carry a logo. People are too sophisticated, says Lagerström, to want to carry around someone else's logo, like so much free advertising.

As a consequence, something unbranded became the most strongly branded piece of communication, as it was the one that people actually wanted to own and take home with them.

The approach works as well for literature as it does for wetwipes. SDL has designed a series of small books for the airline's lounges. Called Scandinavian Words, they are a collection of local myths. Again, these are tastefully understated things, with a small SAS logo only appearing at the bottom of the last page. And they're going down well with the punters. "Frequent travellers are collecting them," says Lagerström.

This minimalistic manner of expression is more Scandinavian than British or American, SDL believes. "It's about over-estimating or under-estimating the audiences in a capitalistic way," he says.

Other projects that demonstrate their approach well are the marque and product range developed for the Swedish association of health professionals, Vårdförbundet. As well as the open-ended cross, SDL was asked to create a new range of merchandise which could be given away at conferences. Instead of pens with logos unthinkingly added, the consultancy came up with a thoughtful selection of products that nurses, midwives and health biomedical scientists might actually want to keep.

SDL is very well respected in its homeland – its packaging for furniture giant Ikea and an identity for Sweden's biggest chain of department stores, Åhléns, are evidence of that.

Its credentials match up to many UK and US consultancies, but it is no small step to break into the international marketplace, particularly as an independent operator.

Right
Scandinavian Words, a series of short-story collections for SAS flyers.

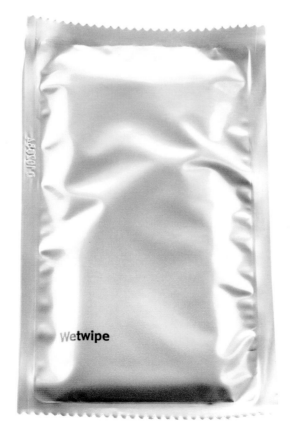

Scandinavian Words

The birth of modern Scandinavian literature can be traced to the years around 1900. The prolific literary output of that period testifies to an age of unrest – intellectual, cultural, social and political. Much in our present-day society is reminiscent of the era. The parallels are numerous and striking. Scandinavian Words is therefore pleased to present the rich cultural heritage from those bygone days to the contemporary reader.

SAS

Right
The airline industry's most popular wetwipe.

Wetwipe

Below
The SAS identity.
Early concept
by FutureBrand.

CASE STUDY
CDT

STICKING TO WHAT
YOU KNOW

The brand and identity developer CDT had a crisis of confidence in the late 1990s. The directors had witnessed many of their peers repositioning themselves from identity designers to branding consultancies, and were worried that clients would stop coming to them. "We became embarrassed to say 'craft'," says Iain Crockart at CDT. However, rather than throwing out everything they stood for, the people at CDT chose to stick to their guns. Instead of bringing brand consultants on board, they set up informal, project-based partnerships with complementary businesses. They have since worked with Brandsmiths, The Fourth Room and Circus.

And Crockart believes that many highly creative people do not stay long in brand consultancies. "Part of the reason people leave big organisations is that they don't want to be run by suits," he says.

The first big project they won against competition and with a partner was the repositioning of the UK's National Lottery Charities Board into the Community Fund. For that job, they worked with Brandsmiths.

Similarly, they partnered with Conran Design Group to create a new identity and interiors for the UK music chain Our Price.

This approach depends on an enlightened client, and according to Crockart there are more such clients around. "Clients are more willing to use partnerships. Now, when a new job comes in we immediately think who we should be working with. We have found the best people in their trade to collaborate with," he says.

Below/Opposite/
Overleaf
CDT's graphics
for Our Price,
with interiors by
Conran Design
Group.

The Japanese marketing communications landscape in some ways mirrors what was going on in the US and UK some 20 years ago. "In Japan, everything is controlled by the ad agencies," says Gwenhael Nicolas of Tokyo multi-disciplinary design agency, Curiosity.

Much of Curiosity's work is in retail. The new Tag Heuer store interiors are their work, as is the latest Issey Miyake concept. The group has also been brought in by Levi's to revamp all 300 outlets of its sub-brand Dockers in Asia.

Nicolas, who is French, studied interior and industrial design. Other Curiosity projects include a mobile phone range, and a perfume bottle design for Jean Paul Gaultier.

When it comes to identity work, designers are often low down the pecking order. "In Japan, the ad agency is the brand guardian," says Nicolas. "The client doesn't care who does the design." But this approach does not necessarily reflect on the quality or the effectiveness of the solutions.

This was certainly the case for Japanese telecomms business KDDI. In order to launch a new company, KDDI went to its ad agency Asatsu to come up with a name. Curiosity was given a couple of days by Asatsu to create an identity for the newly named AU.

"The competition have high tech logos," says Nicolas. "We designed something like an egg for AU, to suggest that from there things will develop, as now technology is taken for granted."

Two years after its launch, AU was the third biggest phone company in Japan.

CASE STUDY
CURIOSITY

GENUINELY
MULTI-DISCIPLINARY

Opposite
Logo for Japanese
telecomms
business AU.

 Brand Identity System

Right
Perfume bottle
design for
Jean Paul Gaultier.

Below left
One of
Curiosity's
concepts for the
new Issey
Miyake stores.

Below
right/Opposite
Curiosity's store
interiors for
watch retailer
Tag Heuer.

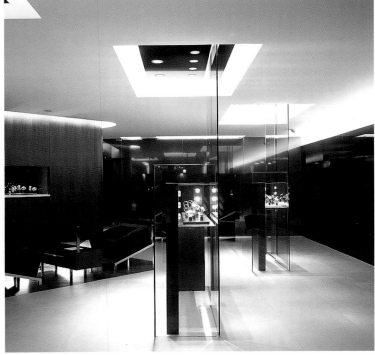

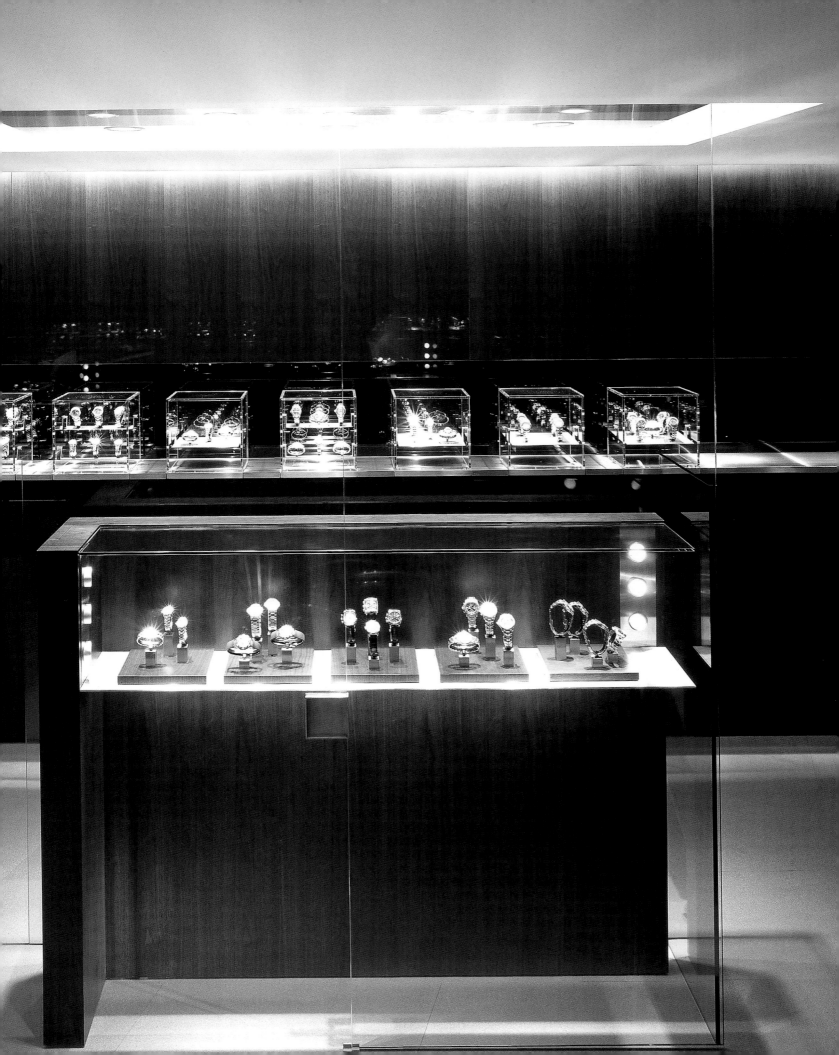

CASE STUDY
HOSKER MOORE
KENT MELIA

APPLYING ART DIRECTION
TO FASHION RETAIL

Hosker Moore & Kent started as an interiors group specialising in retail. Since 2001, they have offered graphics in-house, with the arrival of Colin Melia to create Hosker Moore Kent Melia.

"The more we worked with fashion retailers, the more fascinated we became with the fashion industry; they are masters of image and personality," says Peter Kent, "It's always about the story behind the clothes. So we looked beyond just creating a nice-looking store for them. It had to express the attitude and the personality of the brand."

This attitude and personality stemmed from art direction, so HMK immersed themselves in the visual culture. They started working with the art director and graphic designer Colin Melia on the Italian leather goods brand, Furla. "Colin's approach was holistic," says Kent, taking in the graphics, packaging and the new logo and ad campaign.

Melia, who had created fashion campaigns and graphics for Mulberry, Emanuel Ungaro, Farmacia, Sonja Nuttal and Kurt Geiger, came to work more and more closely with the designers. HMK soon found it difficult to present to clients without going into the whole visual language.

"People were starting to recognise the visual magazine language. We were looking to bring the editorial language into stores," says Kent. In the past, clients would look at interiors and graphics as two very different species of projects. "We said that to get the 360 degree view you need to look at visuals."

The benefits for the client include only having to go through one briefing. Melia explains: "Clients like the fact that they can shop all the elements of a retail space under one roof." And Kent adds that clients appreciate HMK because they can see how all the elements of the project are linked.

As a group with its roots in interior design, HMK's approach to branding is different from that of an ad agency or a full-blown brand consultancy. "In the last ten years, you had advertising or branding consultancies positioning a company, then interior designers came in at the end," says Kent. "But that wouldn't necessarily tally with the way we approach a project. Rather than looking at ABCs and customer research, we do it from instinct. And that's how we got into branding without being a branding consultancy."

The design group is working with Galerias Lafayette, Kurt Geiger and Boots International.

Above left
HMK's UK
store exterior
for Furla.
Photography by
Adrian Wilson.

Above
right/Overleaf
HMK's work for
Kurt Geiger's
autumn/winter
2002 collection.

Above/Opposite
All art direction by Colin
Melia, photography by
Mark Squires and
Samantha Rapp and
styling by Victoria Adcock.

Opposite/Above
UK store interiors
for Kurt Geiger.

CHAPTER 5
VIEWS

WALLY OLINS
JARVIS
MARK RITSON

WALLY OLINS

THE CO-FOUNDER OF WOLFF
OLINS IN THE 1960S. OLINS WAS
WITH THE CONSULTANCY UNTIL
2001. HE NOW CONSULTS AND
LECTURES ON BRANDING AND
RELATED ISSUES.

HERE HE PUTS HIS VIEWS ON THE
MODERN BRANDING BUSINESS,
FROM ITS ORIGINS TO FUTURE
AREAS OF OPPORTUNITY.

Left
Wally Olins

What are the origins of the modern design and branding business?
Brands came from the FMCG sector. They arose 120 years ago through changes like increased literacy, a working class which had some money to spend, and improved distribution channels. You got entrepreneurs who saw a market, and that's how brands began. Some FMCGs – Proctor & Gamble, Nestlé – became very successful and dominated the market.

In those days, design was different because of its roots. Its roots were in the European Bauhaus movement, and were to do with product design and architecture, and the elevation of the taste of the masses. Then designers began to develop commercial aspirations, and were influenced by people with marketing backgrounds. So design companies began to emerge in the UK and US where these two very different and difficult-to-mix traditions tried to integrate.

That's why words that were not familiar in the '70s became familiar in the '80s. So designers talked about identity, and the brand became an idea which spread way beyond FMCG and into other areas.

The more alert design companies tried to work their way through this morass, and along the way they picked up new terminology and recruited people who were unlike and even hostile to their own world. They began to use the techniques of FMCG on a much broader scale.

Then the old FMCG domination of the branding world collapsed, because the media changed and globalisation emerged. Other companies with different ideas of branding came onto the scene, like Nike and The Body Shop. They used the shop and the product and ignored advertising. Retailers like Walmart and Tesco became brands because their relationship with the customer was more intense than the FMCG.

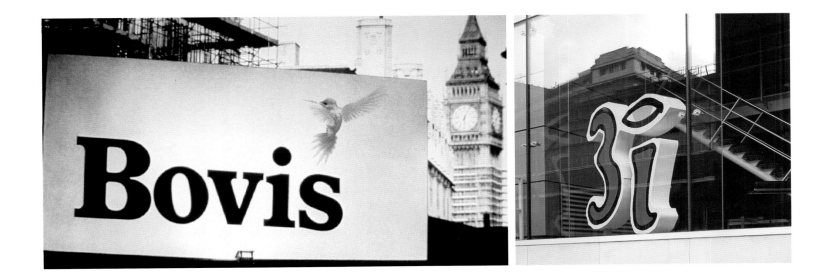

"THE MAIN DIFFERENCE BETWEEN BRANDS IS NOT BUSINESS-TO-BUSINESS AND BUSINESS-TO-CONSUMER, BUT BETWEEN PRODUCT BRANDS AND SERVICE BRANDS."

What is the most significant change in branding over recent years?

The most striking development, which derives from deregulation, is the rapid growth of service branding. It has affected everybody. For example, you now buy a car partly because of the service offered. It's the same with telecomms, infotech and financial services companies. In these kinds of brands, the FMCG experience is not just irrelevant, it's deeply dangerous. Because the assumption of FMCG is that things are the same, but every experience you have with a service brand is different.

This has had a huge impact on the marketing sector. Brand consultancies are now trying to understand that design is sometimes not the most important part of a project, and is sometimes of no significance at all. This is because the behavioural characteristics sometimes dominate to a huge extent.

Meanwhile, advertising agencies are trying to turn themselves into strategic marketing consultancies and are failing.

What is the most important audience for branding?

If the audiences for a brand are not just external but internal, then internal marketing becomes key. In terms of discipline and sweep, it's miles away from what brand consultancies understand.

The whole idea of marketing, that is marketing products to the consumer, only tells half the story. But companies are not set up to really deal with the internal audience. Companies are divided up into these apparently impermeable divisions. It's entirely artificial and ludicrous. You need completely different systems inside a company to make this work. And you have to look very closely when things go wrong, and this must be fed up to the marketing department.

Below
Wolff Olins'
branding for
Orange.

"THERE WILL ALWAYS BE OPPORTUNITIES FOR BRILLIANT INDIVIDUALS. YOU DON'T NEED MONEY TO START UP A CONSULTANCY, JUST GUTS AND CONTACTS."

The main difference between brands is not business-to-business and business-to-consumer, but between product brands and service brands. But the tradition in service branding is so new that no-one understands how to do it. And certainly the brand consultancies and the ad agencies don't know how to do it. FMCG people are responsible for the most appalling mistakes in service industries, because they don't know how to handle service brands.

How will the branding business evolve?
When we started in the '60s, people didn't understand what we were talking about. There was a climate for change, because there were coherent advocates and sophisticated clients. Wolff Olins clients who were sophisticated and courageous were BOAC in the '60s, Bovis in the '70s and 3i in the early '80s. Orange got very close to it with Hans Snook, not that I was involved with it.

The big league brand consultancies are now all owned by the marketing networks.

What impact has that had on the business?
I liken it to Ford, which owns specialised niche brands. Jaguar can be much more Jaguar now because it has the money to express itself. But they lose something: wildness, courage, impetuousness and entrepreneurial spirit. If the networks use their intelligence they can build them into large and complementary businesses to offer their clients a seamless communications business. That's the theory. But in practice, each operating unit will be competitive because each will dominate a territory such as HR. And the quality of the offices overseas varies. The future is good for some but others will fall into mediocrity. There will be a merger between some of them.

What will it be like in 20 years time?
20 years ago there were big companies like Wolff Olins, Pentagram and Landor in the UK, the US and France. They have all merged with big groups but there will be new people starting up.

There will always be opportunities for brilliant individuals. You don't need money to start up a consultancy, just guts and contacts. And there will always be new techniques of marketing to push. It's a moving target, for example e-business is now shown to be just a new distribution system, but it's changed the world.

I believe the idea of creating big companies is no longer relevant. In the early days there were no freelancers, now you can find specialists. This move will completely overtake and render the big businesses dinosaurs, because they are cheaper and faster. Small start-ups will not replace or displace the big companies, rather they will be a very viable option.

We have seen the shift in importance from products to services. What will be the next big thing?
Cities, regions and countries. I'm talking to six or seven nations at the moment, and I believe that I understand it better than anyone else. The essence of a nation's positioning or influence relates to tourism, inward investment and brand export, and is linked to history and tradition. In all this, visual representation is a small or sometimes irrelevant part.

It will be a business that specialists will do, not the branding people. Brand consultancies talk of simple big ideas, but some countries have three or four ideas, and sometimes they are contradictory. You can't distort it by simplifying it, then it becomes a grotesquery. Perception has got to reflect the reality. If you have bad stuff in your history, you can't avoid that. You can't make brands for countries like you make a brand for Mars Bars because the elements are very complex.

JARVIS

HE'S A ONE-MAN-BAND TAKING ON PROJECTS THAT ARE USUALLY DONE BY SWATHES OF MARKETERS AND BRANDING CONSULTANTS.

HOW DOES HE DO IT? AND WHAT DOES THIS SAY ABOUT CLIENTS' REAL NEEDS AND THE FUTURE OF THE BRANDING INDUSTRY?

Left
Jarvis

IT'S EASY TO DEFINE
WHAT HE'S GOT THAT
ATTRACTS CLIENTS,
BUT MORE DIFFICULT
TO EXPLAIN HOW HE
GETS AWAY WITH IT.

In 2001, Jarvis turned down the job of head of image at Nike because it wasn't as all-encompassing as it needed to be. He was behind the global repositioning of the Amex Green Card, and the motoring service RAC in the UK, and is now reviewing the brand of US video game software giant, EA Sports. These are all major roles, which one would expect to be taken on by the arm of some international marketing communications network. And indeed, for the Amex job, he pitched as an individual against the majors. But these were clients which were brave enough to buy into his experience, his attitude and his arrogance.

It's easy to define what he's got that attracts clients, but more difficult to explain how he gets away with it.

Jarvis started his career as a graphic designer, working at Fitch in London and then at Wolff Olins. He worked on the launch of the UK's telephone banking business, First Direct, which was for him as a designer, a seminal point. "In my own way, I started something with First Direct."

After turning his back on the London design scene, he worked at Chiatt Day in New York from 1994 to 1995, starting in strategy and ending up as a planner. Then he had a short stint at Interbrand back in the UK, before going freelance. Strategy, positioning, research and execution – he manages the lot.

He wasn't put off when he didn't get any work for the first year. That was for sleeping and playing tennis in the park. And in fact he turned down any work that he didn't like the look of, and still does.

Jarvis got onto the pitch list for the repositioning of the Amex Green Card by accident, and went on to beat the likes of Ogilvy & Mather, Wolff Olins, Interbrand Newell and Sorrell, and SiegelGale. Of course, as an individual, he hasn't got the overheads of these businesses. But this isn't about undercutting the big boys. Jarvis says he charges pretty much the same as his competitors. The difference is the way the work is handled. In an agency, those people who turn up for the pitch are unlikely to be the ones that actually do the work. That joy will more often than not be passed down to lowlier beings. Jarvis, on the other hand, takes on one major project at a time, and will devote himself to that client. And that, he says, is value for money.

But apart from getting all his attention, a client also gets to draw on his contacts. He's part of that increasing number of smaller specialist outfits who team up with other specialists for specific projects. This flies in the face of the one-stop-shop school of branding – where a client can (in theory) get all their needs catered for under one roof. From identity to product design, interiors to the internal comms, a Fitch or an Enterprise IG would claim to do the lot.

"I SEEM TO HAVE A REALLY GOOD FEELING FOR WHAT'S GOING ON IN THE WORLD, THROUGH GETTING OUT ON THE STREET."

Jarvis describes this as the new "sub-culture" network of highly experienced, highly talented and highly focused individuals and small specialist companies out there. So on the RAC project, he brought in fledgling graphics agency North to create the identity. North was a spin off from Imagination, and the RAC was their first major client. It was only by having Jarvis in place to manage the identity change, that such an outfit would have been able to carry out the work. And while repositioning the UK club and dance music business, Ministry of Sound (MoS), he got Dazed and Confused magazine photographer Rankin to shoot a TV commercial for an MoS dance album.

"That's the New World for me – keeping things fluid, being brave, taking chances, getting top talent in – people who are going to move your own thinking on. It beats sitting behind a desk in Interbrand day in, day out, staring at the ceiling for inspiration," he says.

This, he argues, is where the future is being created: "In the studios of Rankin or Marc Newson – not in the boardroom at Ogilvy or Interbrand."

It sounds too niche or underground for the average consumer, but he believes that these people should be given more credit. The punter has changed to such an extent that conventional agencies are out of touch with them. "People ('consumers') are more marketing aware, more cynical, better informed, more selective and more confident in their own choices. It seems obvious when you look at the amount of media available that we all consume these days."

These more informed consumers are more difficult targets for branding and advertising, he argues. "Conventional marketing doesn't stand a hope of identifying them, let alone understanding them, let alone know how to talk to them."

Below
Application of RAC logo created with North Design on livery and clothing.

And with his lifestyle and approach to branding, he believes he's well placed to understand the consumer. "I seem to have a really good feeling for what's going on in the world, through getting out on the street."

At the same time, clients' needs have changed in such a way that, again, the usual marketing processes are less able to help them. "There's an increasing need for brands or businesses to make giant leaps (often sideways as opposed to simply forwards) rather than incrementally 'tart-up' a product or brand," he says. "Increasingly, clients want to buy ideas and insight rather than a process, a product or client servicing." And that's what he tries to do: "Cut away all the crap and just deliver the breakthrough ideas, insight and vision. That's where the real value and competitive advantage is for the client."

And as an individual, he can be fleet of foot, something which clients who are used to the laborious progress of their agencies, appreciate. "Most agencies tend to put large teams onto things and you get a lot of waffle and presentation by committee," says Dominic McKay, international head of product development at Amex.

This contrasts with many of the solutions that he sees out there, particularly in the way they're executed. Big ideas executed simply by specialists – that's Jarvis' approach. "That runs contrary to the conventional model which is to take a simple (or simplistic) idea and execute the hell out of it."

These are all very seductive arguments, but it is still a courageous client that ditches the agency in favour of the individual. But then, he's not interested in clients who want to play safe. "I'm really interested in working with visionary, brave people rather than with high-profile brands per se. You're only ever as good as your client."

And one thing that Jarvis' clients get is honesty by the bucketload. For he is not in the business of mincing his words. "Independence allows you to be a lot more honest with the client. I find that a much more modern way of working."

That approach certainly suited McKay: "Jarvis had complete integrity, rather than trying to say what he thought we wanted to hear."

Above
Proposal for American Express cards created with 8vo Design.

MARK RITSON

AS PROFESSOR AT LONDON BUSINESS SCHOOL, RITSON SEES A BATTLE BEING WAGED WAY BEYOND LOGO, THE FIGHT NOW BEING FOR FOR THE CLIENT'S BRAND.

HE WHO CONSULTS MOST CONVINCINGLY ON THE BRAND WILL BE DECLARED WINNER, HE BELIEVES, AND WILL HAVE THE MOST POWERFUL POSITION WITH THE CLIENT.

Left
Mark Ritson

Professor Mark Ritson lectures in brand management at London Business School. He also acts as a consultant for clients such as Ericsson on brand issues. For him, there is a three-way struggle taking place to own the client's brand. And the type of business that gets the ear of the CEO on branding issues will be the winner.

Clients recognise that their brand is the make-or-break element of their business. It's more difficult to compete on price, quality is much of a muchness, so that leaves the brand.

The three groups that are battling it out are the management consultancies, the ad agencies and the brand consultancies. The management consultancies have in recent years built up branding arms, the ad agencies are repositioning to focus on brand strategy rather than on TV commercials, and the brand consultancies are distancing themselves from the logo. These three are being more or less successful at their repositionings, and no one group has yet come out on top.

Not one of them is yet in a position to offer everything a client needs in terms of its brand, although some may profess to do so. "It's a case of everybody bluffing in a poker game," says Ritson. While advertising doesn't know how to express strategic issues, the management consultancies are unsure how to incorporate brand into their systems. And the brand consultancies themselves are still "too small and boutiquey". Even the ones that are part of massive international marketing networks are small compared with the ad agencies and management consultancies.

"Consultancies like Enterprise IG and Landor don't have global reach and they focus too much on design rather than strategy," he claims. And while they may purport to offer some of the services of the management consultancy, Ritson is dubious. "I question brand consultancies' research skills. Having the token research guy is not good enough." In the meantime, confusion reigns for the client. "Clients know that it's all about brand, but they don't know who to bring in," he says.

Just as there are three rivals, there are three roots to the current confusion, according to Ritson. Each group,

and sometimes different firms within each group, give different meanings to the different key words. Brand, identity, value, strategic creativity, creative strategy. They all get bandied around, and often with different definitions, depending on who is speaking.

The second problem is one of measurement, he says. Each supplier wants to measure the effectiveness of their offer, but each is measuring in a slightly different way, meaning it's difficult for a client to compare like with like.

The third issue is brand equity. This, he argues, should reveal different things for different clients. "Everyone wants to come up with some generic system for branding, but in branding, generics don't exist. Every brand is unique," he says. All these trademarked systems for creating and measuring brands are confusing clients, he says. But then, perhaps that's what the consultancies want. For a baffled client may be seen as an easy client.

Regardless of their claims and counter claims, Ritson doesn't think any one group is yet supreme. "They all give you something, but none gives you everything. My advice to clients is to use all three groups, but you have to build your own brand. The one-stop-shop doesn't exist." In the meantime, Ritson's money is on the management consultancies to come out on top. "The big management consultancies want to win the battle most badly," he says. "They want brand management more than anyone because if they win a client's brand it opens up avenues to other bits of their business."

It could be this sector, he suggests, which goes on to create the all-encompassing super group. "They've certainly got the cash to do it." And if clients are bewildered in the meantime, they have only them-selves to blame, he says. "The reason consultancies began to offer integrated marketing ten years ago is because clients demanded it. You have to blame the clients, and yet now they don't know what they want."

ACKNOWLEDGEMENTS
KATE ANCKETILL AT GDR,
RALPH ARDILL AT IMAGINATION,
JACOB BENBUNAN AT
SAFFRON, RICK BOLTON AT
FRESH*MACHINE, BRAGA
ORIS, DEBORA CHATWIN AT
ENTERPRISE IG, IAIN CROCKART
AT CDT, WILL DOWDY, FACTORY
DESIGN, MARIO GAGLIARDI
AT ALLEVIO, BRADLEY HERMAN
AT ISH, INTERBRAND, DAN
JACKSON AT SONICBRAND,
JAM, JARVIS, PETER KENT AT
HMKM, PETER KNAPP AND
PIPPA KNIGHT AT LANDOR,
DON LANDERS AT SPRINGETTS,
JOHN MATHERS AT FITCH,
DEBORAH MAXWELL AT THE
POST OFFICE, TIM MAY AT
DESIGN HOUSE, DAVID
MERCER AT BT, NICK MOON
AT FUTUREBRAND, JANE
MUSSARED AT ALLIED DOMECQ,
GWENHAEL NICOLAS
AT CURIOSITY, MARK NORTON
AT 4I, WALLY OLINS, PHILIP
ORWELL AT LUCKY, TIM
PARSEY AT MOTOROLA, LYNDA
RELPH-KNIGHT AT DESIGN
WEEK, MARK RITSON AT
LONDON BUSINESS SCHOOL,
PIERS SCHMIDT AT THE
FOURTH ROOM, ALAN SIEGEL
AT SIEGELGALE, SQUIFFLE,
STOCKHOLM DESIGN LAB,
NICK SWALLOW AT FURNEAUX
STEWART, BARBARA
TISCHHAUSER AT SWISS,
MATTHEW WARREN AT WINK,
CHARLES WRIGHT AT
WOLFF OLINS.